FOREWORD

Public sculpture is the most celebratory and commemorative of art forms. The repository of communal memory, the record of heroism, martyrdom or vainglory, it speaks to us more directly than any other element of the historic environment. The question of what goes on the fourth plinth in Trafalgar Square has been the subject of a 158 year debate and still no one can decide.

Antony Gormley's Angel of the North has inspired vigorous and widespread controversy. As a result we have become a more visually aware nation in which we are all entitled to an opinion about the size and shape of new additions to the landscape, to our town squares and street corners.

By opening our eyes to the monuments which past generations have seen fit to bestow upon us, I hope that this User's Guide will provide a context to the debate that grows daily over the many - some say too many - new works appearing all around us.

There is nothing quite like it. Put on your walking shoes and with your umbrella in one hand and our Guide in the other, I hope you will explore England's eponymous collection of outdoor art - and enjoy it!

I am most grateful to the Public Monuments and Sculpture Association who have written and researched this book and in particular to its Director, Johanna Darke.

My sincere thanks also go to Antony Gormley for his support and to Richard Cork for contributing such a thought-provoking introduction.

Sir Jocelyn Stevens
Chairman of English Heritage

CONTENTS

Art is not an amenity but a necessity.
Antony Gormley

Only two months after the octogenarian Queen Victoria finally died, in January 1901, a provisional committee swifly began planning a national memorial to her formidable sixty-three year reign. Like Albert before her, Victoria was deemed worthy of a monument on the grandest imaginable scale. Conceived in tandem with an architectural reshaping of the approach to Buckingham Palace by Aston Webb, the Queen Victoria Memorial was intended from the outset as an unabashed celebration of imperial magnificence.

At its heart sits the marble monarch herself, the implacable 'regina imperatrix' flanked by the winged figures of Truth and Justice. While she gazes sternly up the Royal Mall towards the newly designed Admiralty Arch at the other end of the thoroughfare, a carving of Motherhood faces the Palace to remind the nation of the Queen's prowess as the bearer of nine children. Crowned by an ostentatiously gilded bronze Victory, who flaunts outsize wings above the figures of Courage and Constancy, this swaggering centrepiece was the work of Thomas Brock. When the memorial received its elaborate ceremonial unveiling in May 1911, attended by the Kaiser and countless other members of Victoria's extended European family, the King promptly knighted Brock in the Palace. Royal approval was not, however, matched by the reaction outside monarchical circles. The growing impatience with overblown monuments prompted an acerbic comment in the Architectural Review: 'though the piling together of tons of marble and bronze may ... perpetuate the memory of a sovereign or statesman, it may also, in the eyes of posterity, be regarded as a mausoleum for the reputation of the sculptor'.

A USER'S GUIDE TO PUBLIC SCULPTURE

The waspish comments could hardly have been more prophetic. For all its bulk, extravagance and technical finesse, Brock's tour de force has not guaranteed him a posthumous reputation commensurate with his standing at the end of the old Queen's reign. By 1911 the Victoria Memorial was already coming to be seen as a pompous anachronism, a tired product of the old century rather than a harbinger of the new. The emergent generation was impatient with the whole notion of public sculpture practised by a portraitist as somnolent as Sir Joseph Edgar Boehm. He had been Sculptor in Ordinary to the Queen during Victoria's reign, when the demand for effigies of imperial grandees, politicians, magnates and aristocrats was voracious. Boehm's bronze statues of dignitaries as imposing as Lord Lawrence, Governor of the Punjab during the Indian Mutiny and subsequently Viceroy of India, peppered civic squares in numerous British cities.

They became so ubiquitous that, by the time the avant-garde Vorticist movement launched a rumbustious onslaught on the 'years 1837 to 1900', its members were ready to shout their determination to 'BLAST pasty shadow cast by gigantic Boehm (Imagined at introduction of BOURGEOIS VICTORIAN VISTAS)'. To Wyndham Lewis and his young Vorticist allies, engaged in a radical overhaul of British art just before the First World War, the 'wheeping whiskers' adorning so many of Boehm's bronzes symbolised the intolerable complacency of a sculptural tradition guttering to an ignominious close.

The Vorticists' fury was fanned by their realisation that, in the public sphere at least, any attempt to depart from the Boehmian sculptural norm was likely to be denounced and threatened with destruction. Jacob Epstein had undergone just such an ordeal when he made a series of carved stone figures for the new British Medical Association headquarters in the Strand, designed by the rebellious architect Charles Holden. The sequence of statues amounted to one of the most ambitious sculptural cycles ever installed on a British building.

In 1908 Epstein, writing for the British Medical Journal, explained that 'I have wished to create noble and heroic forms to express in sculpture the great primal facts of man and woman'. Both he and Holden were excited by Walt Whitman's poetry, and in particular his hymn to physical exultation, 'I Sing the Body Electric', where the poet declares:

'If any thing is sacred the human body is sacred.'

The finest carving in the BMA series, Maternity, was a bare-breasted affirmation of the qualities celebrated by Whitman in the same poem when he extolled:

'Womanhood and all that is a woman, and the man that

comes from woman,

The womb, the teats, nipples, breast-milk, tears, laughter,

weeping, love-looks, love-perturbations and risings.'

At the same time, though, Maternity derived much of its appeal from the unassuming, instinctive grace of woman and child alike. So it is ironic indeed that such a modest image became the initial focus of the controversy which suddenly overcame the entire venture.

In the early summer of 1908, the arrival of Maternity was noticed by the National Vigilance Association, whose offices happened by some bizarre coincidence to be directly opposite Holden's building. They were incensed by the figure's generously proportioned body, and lost little time in reporting this outrage to the press. The London Evening Standard was happy to present the 'scandal' to its readers with a front-page headline, 'BOLD SCULPTURE. AMAZING FIGURES ON A STRAND BUILDING. IS IT ART?' The lead story announced that Epstein's carvings 'are a form of statuary which no careful father would wish his daughter, or no discriminating young man, his fiancée, to see'. It was a farcical assertion, and no attempt was made to reveal precisely why a mother and child should be considered so obscene. But the Evening Standard did maintain that Edwardian society expected its artists to observe a strict sense of decorum whenever they moved outside the gallery and executed work for an open-air site. 'Nude statuary figures in an art gallery are seen, for the most part, by those who know how to appreciate the art they represent', the newspaper declared, before arguing that 'to have art of the kind indicated, laid bare to the

gaze of all classes, young and old, in perhaps the busiest thoroughfare of the Metropolis of the world ... is another matter'.

The furore reached such a pitch of hysteria that crowds gathered beneath the statues, and a Catholic priest claimed that Epstein's carvings were provoking 'vulgarity and unwholesome talk, calculated to lead to practices of which there are more than enough in the purlieus of the Strand already'. By this time the accusations had become absurd, and the perplexed young sculptor must have been very relieved when an impressive army of critics, museum directors and artists came to his aid. They persuaded the British Medical Association to abandon its plan to censor the statues. But Epstein himself was shaken by the acrimony his work had aroused. The unease would linger throughout his life, and the BMA scandal ensured that he did not receive another architectural sculpture commission for twenty long years.

The uproar contributed to the eventual downfall of Epstein's statues. In 1935 Holden's building was purchased by the Southern Rhodesian Government, and soon afterwards the High Commissioner announced that all the carvings would be taken down. His official reason, was that 'they are not perhaps within the austerity usually appertaining to Government buildings'. But beneath the diplomatic camouflage lay the same objection which the National Vigilance Association had expressed in 1908. An elaborate campaign was once again mounted in the statues' defence, but two years later a fragment from one of the figures crashed onto the pavement. The building's owners seized on the incident, and refused to consult Epstein on the best way to make

his sculpture safe. Nothing could now prevent a group of callous inspectors, who very surprisingly included Holden, from examining each figure and hacking away any section considered to be dangerous. No attempt was made to repair the butchered carvings, and the terrible mutilations are still exposed in all their rawness on the building today.

Since then, plenty of other sculptors have encountered bursts of hostility and vandalism when they were brave enough to install their work in public spaces. Henry Moore's carving of a family group suffered a particularly severe attack when on view in Harlow New Town, and a Barry Flanagan sculpture was entirely wrecked on an open-air site in Cambridge. Among the recent victims is Rachel Whiteread's House, one of the most outstanding sculptures ever produced for a public space in Britain. For a few months at the end of 1993, it gave not only the Bow neighbourhood in the East End of London but the whole nation a focus for intense debate. The arguments were as impassioned as the polemic generated by Epstein's carvings eighty-five years before. But Whiteread's masterpiece was expunged from Grove Road with surgical efficiency, by a local council determined that her work would not 'desecrate' the park newly created on the site. Its enigmatic presence became a focus for the indignation of those who saw the sculpture as nothing more than a rehash of a Brutalist building from the 1960s.

Like the vilification hurled at Epstein's statues in the Strand, these accusations could hardly have been more misplaced. My own recollections of repeated visits to House centre on its reticence, air of understated vulnerability and preoccupation with death. The projecting windows at the front were clearly identifiable, but they all looked sealed up. So did the ascending ranks of fireplaces imprinted on the south side. Memories were stirred of Pompeii, as if the entire building had been engulfed and petrified by an avalanche of lava. By turning private space into a public memorial, by making emptiness take on an eerie solidity, by transforming a home into a sepulchre and finding expressive form for her preoccupation with the irrecoverable past, Whiteread produced an austere yet haunting monument that touched on all our lives.

But even as we continue to lament the loss of House, other adventurous sculpture has taken root in prominent locales across the country. Birmingham's Victoria Square used to be dominated by Thomas Brock's statue of the imperial Queen. But now, rescued from decrepitude, she finds herself juxtaposed with an intruder: Antony Gormley's 20-foot Iron:Man, commissioned by TSB Bank for a position outside their new headquarters in the square. Cast in four sections and embedded in the ground up to his ankles, Gormley's strangely mummified figure was conceived quite independently from the rest of the redesigned area. But its disconnectedness is hugely stimulating. Leaning both backwards and to the left, Iron:Man has the power of a phantom. Partially submerged in Birmingham's past, or

perhaps re-emerging like Lazarus from underground oblivion, this featureless Everyman hovers on the borders of the civic splendour around him. He offers a plainspoken, brazenly bolted corrective to the ceremonial pomp of Brock's Victoria, and his rusting body-case provides an implicit reminder of the city's former industrial prowess. His presence here is salutary, questioning the role of public sculpture today and lending a rough, provocative edge to a square that might otherwise have lapsed into polished complacency.

The dangers attendant on working in such an exposed location should never lead artists to play safe. Bland sculpture swiftly becomes ignored after its installation, whereas boldness helps to ensure a stimulating relationship with passers-by. Take Bottle of Notes by Claes Oldenburg and Coosje van Bruggen, erected with admirable enterprise and aplomb in the centre of Middlesbrough in 1993. Soaring nearly thirty-five feet into the northern sky, and leaning at the same tipsy angle as the Tower of Pisa, this eight-ton monument in tempered steel is the first sculpture commissioned from Oldenburg and van Bruggen for a site in Britain. It takes as a springboard the town's association with Captain Cook, whose pioneering expeditions fired

Oldenburg's imagination at once. His fascination with the idea of a ship in a bottle fused with van Bruggen's interest in an Edgar Allan Poe story about a sailor who, having written an account of a nightmarish voyage, bottles his text and hurls it into the whirling vortex of the sea.

Although Oldenburg and van Bruggen avoided the melodrama and morbidity of Poe's Gothic tale, they incorporated the form of the vortex in their sculpture. And they ensured that writing played a powerful role, too. While the cork remained paradoxically intact, the rest of the bottle would be made solely of the words it contained. The sentence wrapped like an off-white lattice round the bottle's circumference comes from Cook's journals, where he describes his excitement at watching an eclipse. And the blue-painted poem within conveys van Bruggen's lyrical childhood memory of seagulls flying over a ring of canals. On a personal level, the two texts shed light on the relationship between her and Oldenburg. Taking turns to 'eclipse' each other, the male and female passages are nourished by their intertwining. But the two sets of writing still remain separate, in colour and rhythm alike. Oldenburg's angular handwriting ensures that Cook's sentence seems to be driven by the surge of the sea and the force of the wind. But van Bruggen's rounded handwriting gives the words inside an astonishing vivacity. The holes puncturing Bottle of Notes encourage us to step inside the sculpture, and there the words spin above our head with dizzying force.

Outside, the sculpture's tilt conveys a sense of precariousness as well. It suggests that Bottle of Notes might have been washed ashore and beached there by a receding wave. In the end, though, vulnerability plays second fiddle to energy and resilience.

The daring open structure, cocking a snook at the whole notion of traditional sculptural solidity, pays homage to Middlesbrough's celebrated Transporter Bridge. Its tensile strength encouraged Oldenburg and van Bruggen to think in terms of an object defined essentially by line. Drawn in space with flamboyant and rigorously refined assurance, the sculpture also testifies to the fabrication skills of the region. Middlesbrough is proud of the fact that such a distinguished work was made locally, and that the town has set such a challenging new standard to the rest of Britain with this provocative, multi-layered and yet crisply accessible monument.

The precedent created here proves, with eloquent authority, that more artists of similar calibre should be encouraged to venture beyond the gallery's limits in the future. If they are given spaces that stimulate their energies rather than confining them, and receive the support of architects, planners and patrons motivated by an informed understanding of the pitfalls as well as the enormous possibilities, our towns and cities will have everything to gain from placing the finest art at the very heart of modern life.

Richard Cork

Sculpture pays not a little attention to the resemblances, in fact requires them but it does not seek them above all else. What it has sought in the great epochs is the gesture, expression, or the empty glance that contains all gestures and glances around the world.

Its intention is not one of imitation but of stabilisation, to catch in one significant expression all the passing furore of the body and its infinite variations of attitude. Only then does it erect on the pediment above the tumultuous city the model, the type, the perfect immobile symbol, which for a moment, cools the incessant fever of man.
Albert Camus

There is no background better than the sky, because
you are contrasting solid form with its opposite - space.
Henry Moore

What can sculpture do? It can concentrate a part of the material world which metaphorically reaches out a hand and says *'be with me a while and live more intensely'*. Sculpture for me is a reinforcement of the physical in order that life itself should become more intense.
Antony Gormley

Location is critical to the success and accessibility of public art. The gathering of art in clusters and in places of shared significance of memory eases the burden of interpretation, though it says nothing about the artistic quality of the piece. The sole work of art attempting to lighten or dignify the urban wilderness has a much heavier burden of interpretation to bear. It's altogether a tenser kind of performance, and correspondingly we're quicker either to admire or despise it.

When the culture is comfortable with itself, the expression of art in our streets is tolerably unselfconscious. A statue to a great man or woman, or at the other extreme the petty architectural decoration on traditional buildings, is a natural manifestation of what is thought right. It is merely what is done, and in the view of those who order these things, needs to be done for its own sake.

ART BEYOND THE GALLERY

There may be differences of opinion over it, but the culture does not agonise deeply over either its meaning or its artistic quality. The didactic strain has always been there in public art but is always fragile. It can serve memory, respect, an appeal to civic energy and commutarianism or any other aim of public education or discipline. When it is pushed too far, it betrays some anxiety in the culture and goes wrong. It then collapses into a kind of display of public virtue and like all forms of display of erudition, becomes the very opposite of teaching - and we become aware of its elitism and esotericism.

When on the other hand no didactic purpose is present, authority is lost and public art stands in danger of becoming gestural and ephemeral. The relationship between public art and public utility has always been haphazard and continues to be disappointing. I confess I don't understand why we cannot make this connection better.

Much modern public sculpture derives, consciously or not, from a sense that the public must be compensated for being deprived of all that unmeaningful incident and variety of carving and moulding that used to adorn even the least significant of our buildings. The art element is sucked off the face of the building and gathered up in a great contrapuntal gesture where meaning and pleasure and art and money are concentrated. Often this is too much for the work of art to bear.

The shift in our cities from the authoritative to the expressive view of public art - that what matters above all is the artistic quality of the object - has taken place with astonishing speed, really only since the Second World War. It's been an uneven process, and the take-over of values has never been complete, because the value system of art is inadequate to expressing the complex needs of public life. The more recent fashion for giving accessible art back to communities by means of populist, participative and compensatory gestures is a point of compromise between the authoritative and self-expressive cultures, but offers no guarantee of stability.

Andrew Saint

The monument sticks like a fishbone in the
city's throat.
Robert Lowell - For the Union Dead (1917-77)

The commissioning of public art in the past 20 years has done much to bridge the gap of incomprehension between the arts establishment and the majority of the public.... At the same time, sculptors have been made to think about the public who will see their work.
Alan Powers

LOOKING AT SCULPTURE: THE DODGER'S GUIDE

Street-cred

be comfortably clad

carry a good local map

shopping and sculpture walks (two good

things) don't mix

What's out there

look up - buildings have sculptures

double-decker buses bring you close

the back of a statue can be well worth

a look

Watch out for

the sculptor's signature - scratched into the bronze

base, or perhaps on the hem of a coat, or the side

of a shoe

the name of the sculptor or the name of the

foundry, often inscribed on either side of the

figure's base

personal details - an umbrella, spectacles, a fob

watch, especially in Victorian sculptures like Sister

Dora, Walsall (her nursing scissors on a ribbon)

new materials, new combinations in

sculpture -neon, glass, plant-life

Visual aids

carry miniature binoculars or opera glasses for

viewing elevated personages

dark corners, close-to, can be lightened by

bouncing light off a piece of white paper

shadowed parts higher up look lighter through a

funnel made with your fist for one eye

Photographers

a zoom lens is better fun

Practicalities

carry a plastic bag for note-taking in the rain

enthusiasts, don't climb on the sculpture

don't step backwards under a bus

ALWAYS CARRY YOUR USER'S GUIDE!

Every man has a lurking wish to appear considerable in his native place.
Dr Johnson quoted on the pedestal of his statue in Litchfield, his birthplace

When it's good work it can enrich and enhance
an environment.
Public 25.02.00.

Public Sculpture doesn't always feel prescious
you can touch it.
Public 20.02.00.

The revival of interest in sculpture is a happy coming
together of the artistic, the commercial and the idealistic.

The Arts Council has done its bit realising that if people will
not visit galleries they can hardly avoid art in shopping malls,
or on trips into the country.
Antony Thorncroft

Statues should be put back where they really belong. Go to the Louvre for example, drag one of those Egyptian colossi out of its somnolence, and then set it up in the heart of a crowded neighbourhood.
Pablo Picasso

John Humphries:
Alright, Alison Wilding, just a final question for you:
Is it art? I mean, it's the age old question - we ask it probably
every month on this programme! Is it art?

Alison Wilding:
Yes I think so, but I don't know that that's a terribly interesting
question.
The Today Programme on Alison Wilding's floating piece,
'Ambit', under the bridges in Sunderland

By far the most original contribution of Victorian Britain to world culture was - the public statue.
Benedict Read, Chairman PMSA, Author - Victorian Sculpture, 1982

Our statues are loved by neglect.
AA Gill

Move Queen Anne? Most certainly not! Why it might some day be suggested that *my* statue should be removed, which I should much dislike.
Queen Victoria
Said at the time of her Diamond Jubilee (1897) when it was suggested that the statue of Queen Anne should be moved from outside St Paul's

The moment of putting a statue up to someone causes people
to pay attention to that person for the rest of time.
Celina Fox

Swans in Flight
by David Wynne
bronze, 1968
Civic Centre
Newcastle-upon-Tyne

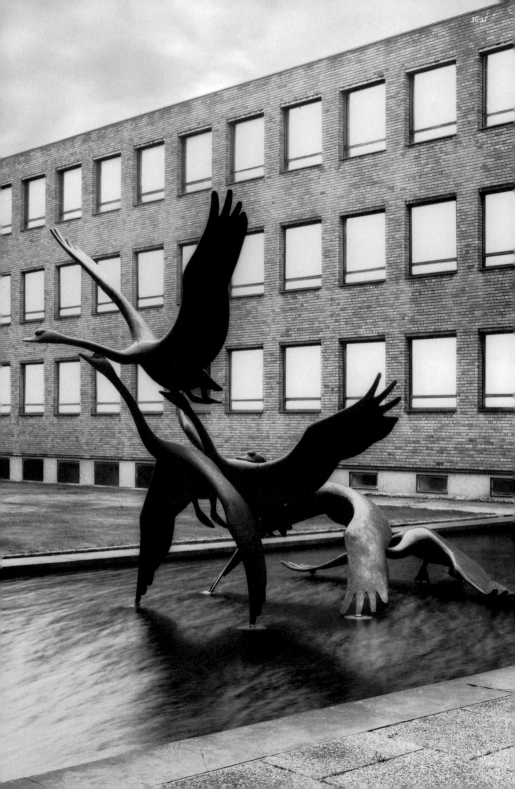

River God Tyne
by David Wynne
bronze, 1968
Civic Centre
Newcastle-upon-Tyne

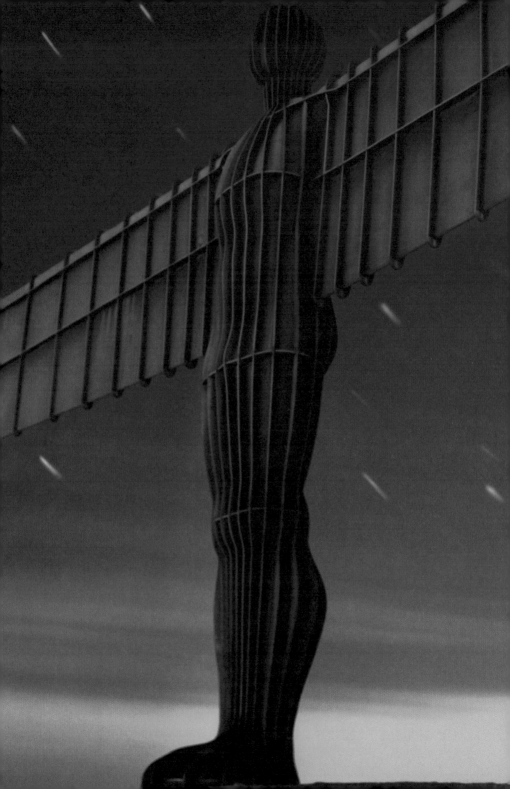

Angel of the North
by Antony Gormley
Cor-Ten steel, 1998
near Gateshead
Newcastle

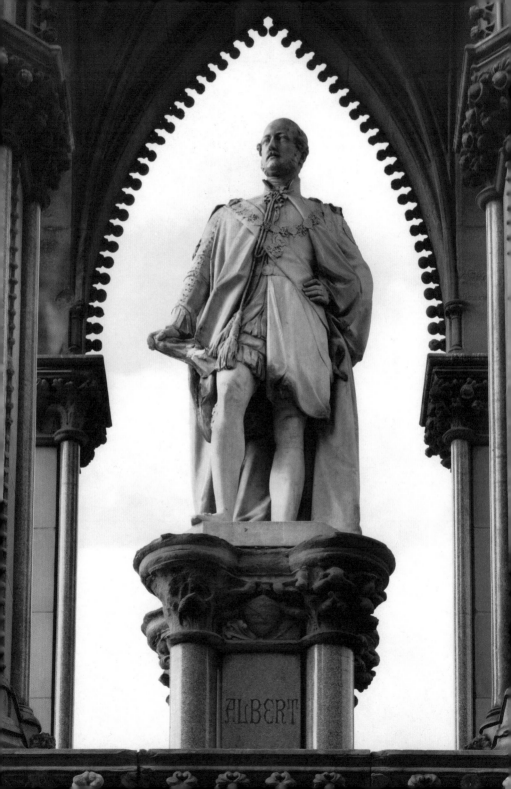

Albert Memorial
by Matthew Noble
marble, 1867
Albert Square
Manchester

Motherhood
by Onslow Ford
bronze, 1901
Piccadilly Gardens
Manchester

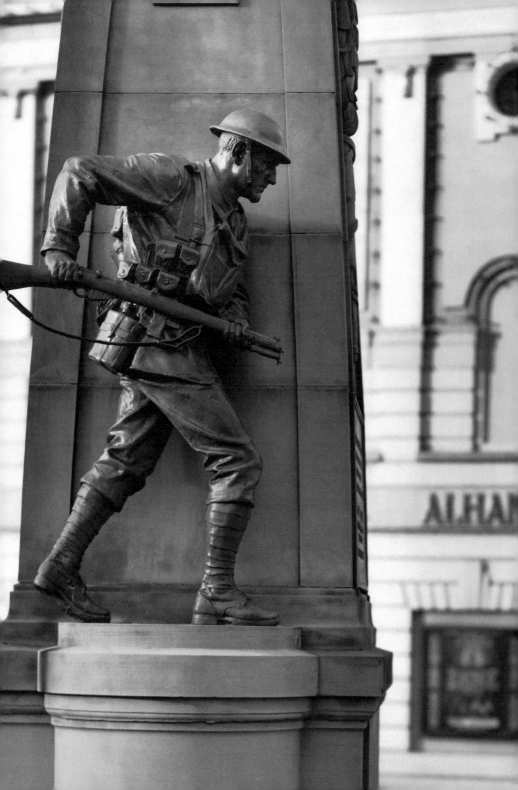

War Memorial
by Walter Williamson
bronze and stone, 1922
near the Alhambra Theatre
Bradford

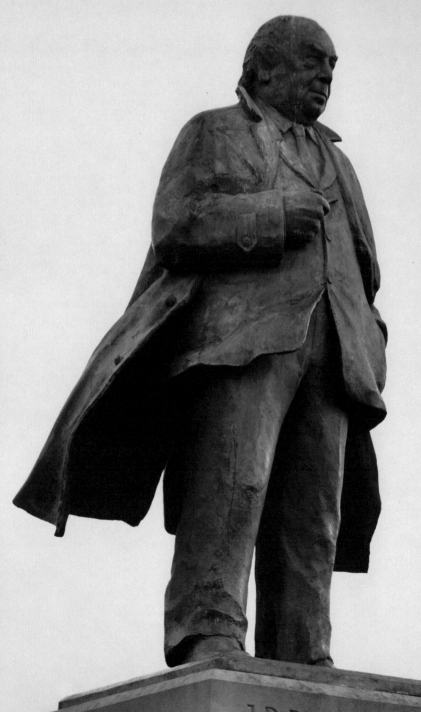

AUTHOR J.B.PRIESTLEY O.M

J.B.Priestley
by Ian Judd
bronze, 1986
City Library
Bradford

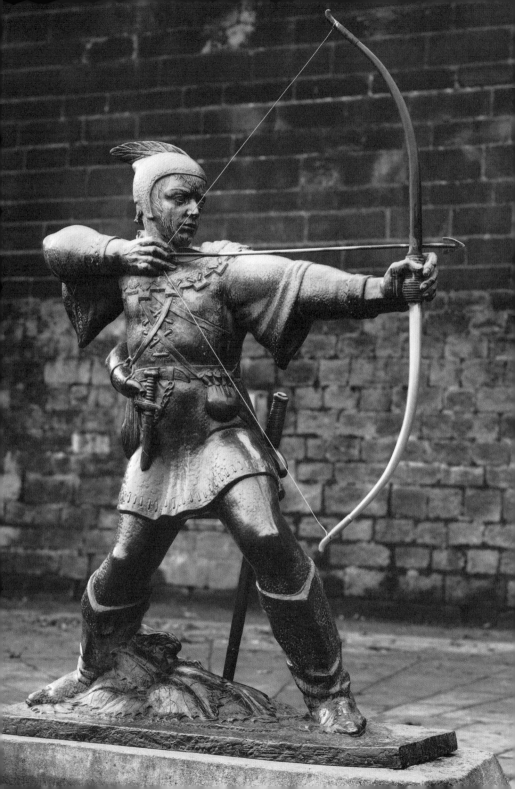

Robin Hood
by James Woodford
bronze, 1952
Nottingham Castle

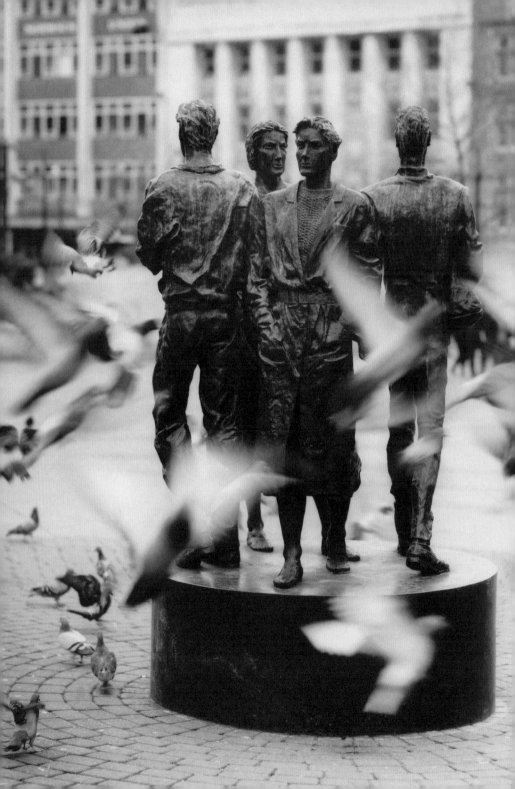

Quartet
by Richard Perry
bronze, 1986
Old Market Square
Nottingham

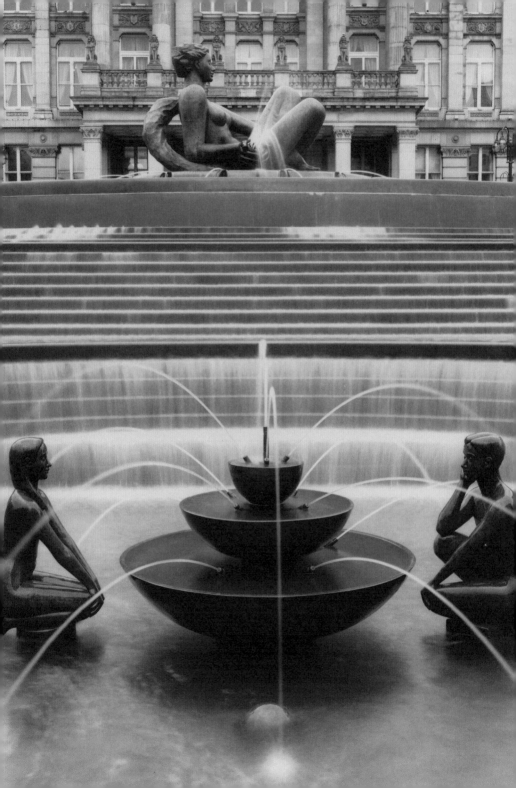

River, Youth, Guardians and Object (Variations)
by Dhruva Mistry
bronze and sandstone, 1993
Victoria Square
Birmingham

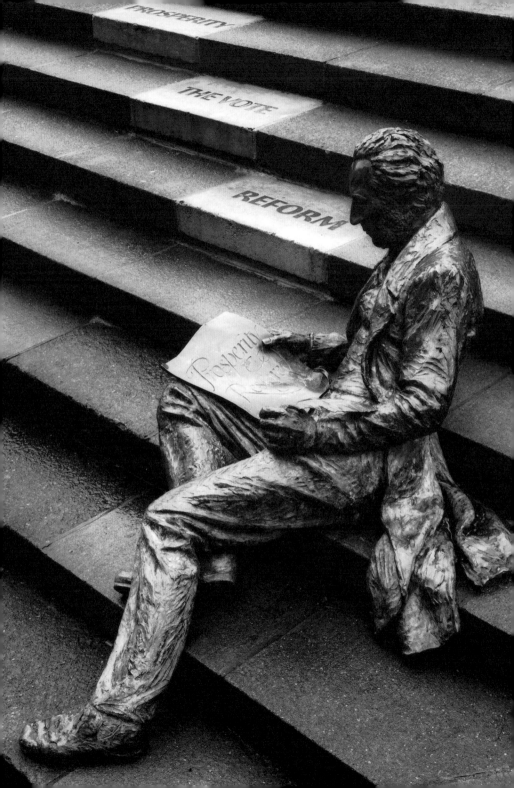

Thomas Attwood
by Sioban Coppinger and Fiona Peever
bronze, 1993
Chamberlain Square
Birmingham

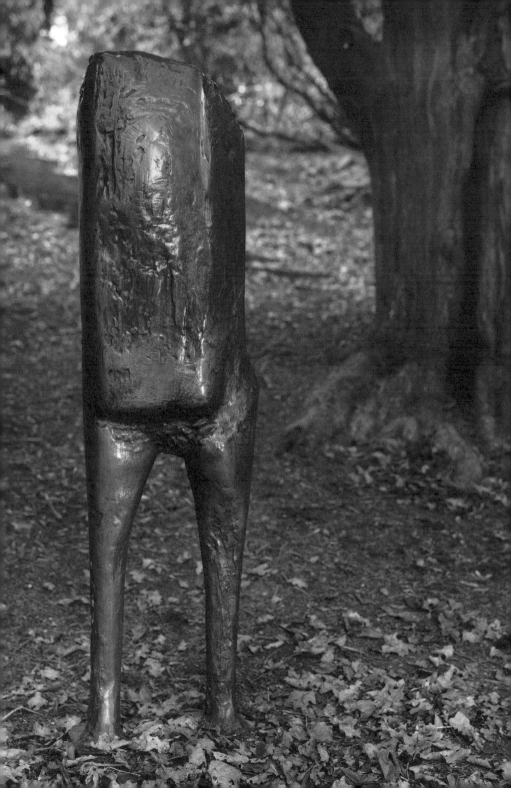

Standing Figure
by Kenneth Armitage
bronze, 1961
Jerwood Sculpture Park
in association with English Heritage
at Witley Court, Worcestershire

Walking Man
by Elisabeth Frink
bronze, 1986
Jerwood Sculpture Park
in association with English Heritage
at Witley Court, Worcestershire

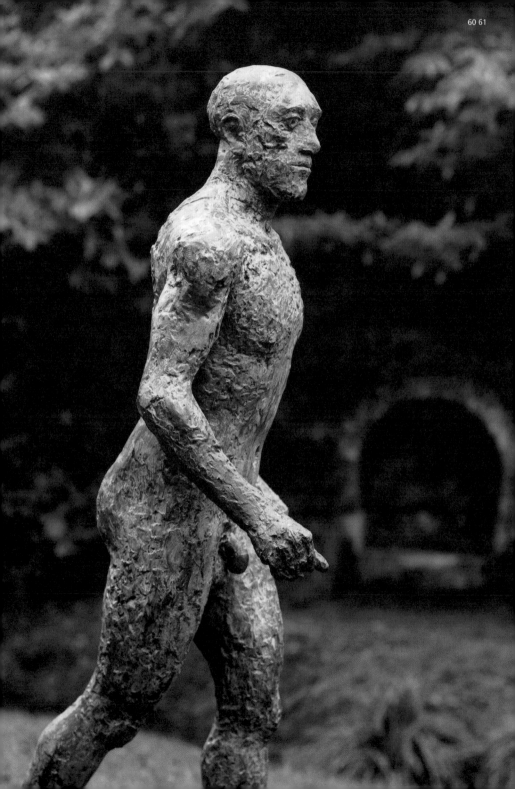

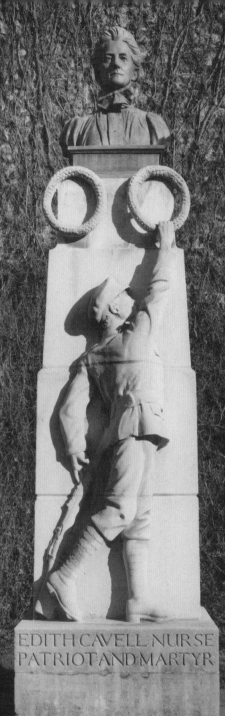

EDITH CAVELL NURSE
PATRIOT AND MARTYR

Monument to Edith Cavell
by Henry Pegram
bronze and Portland stone, 1918
Tombland
Norwich

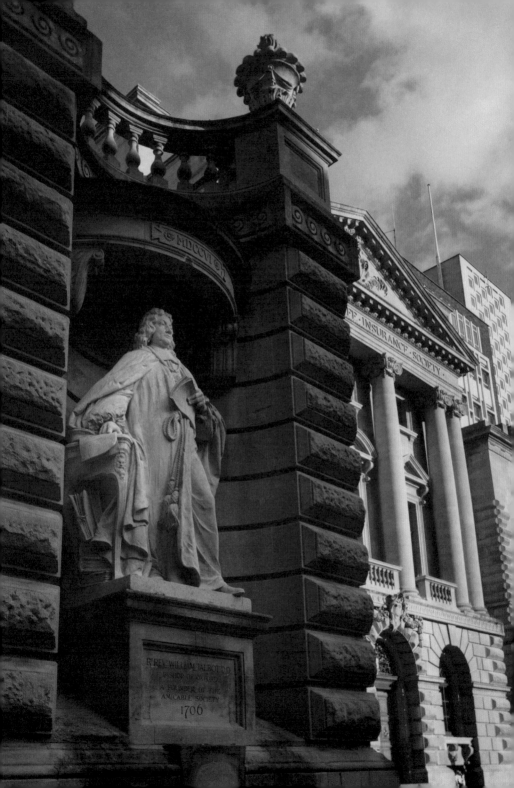

Bishop Talbot
by L. Chavalliaud
Portland stone, 1904
Surrey Street
Norwich

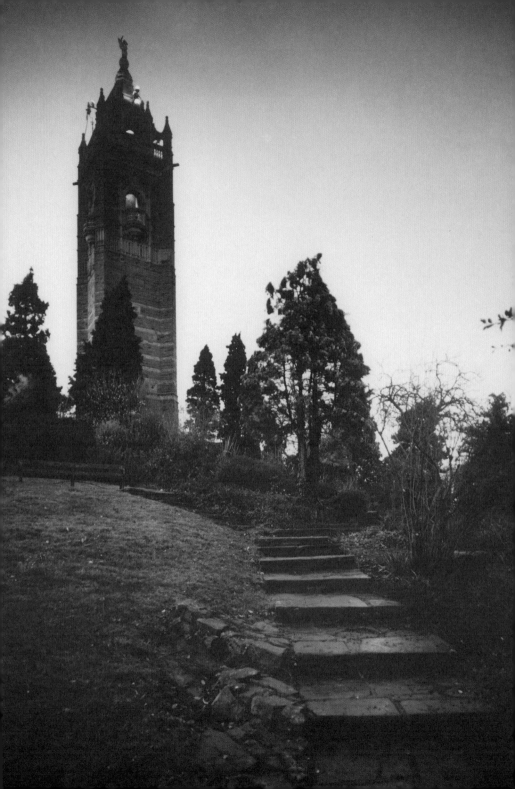

Cabot Tower
by W.V. Gough
Sherwood sandstone
and limestone dressing, 1897
Brandon Hill
Bristol

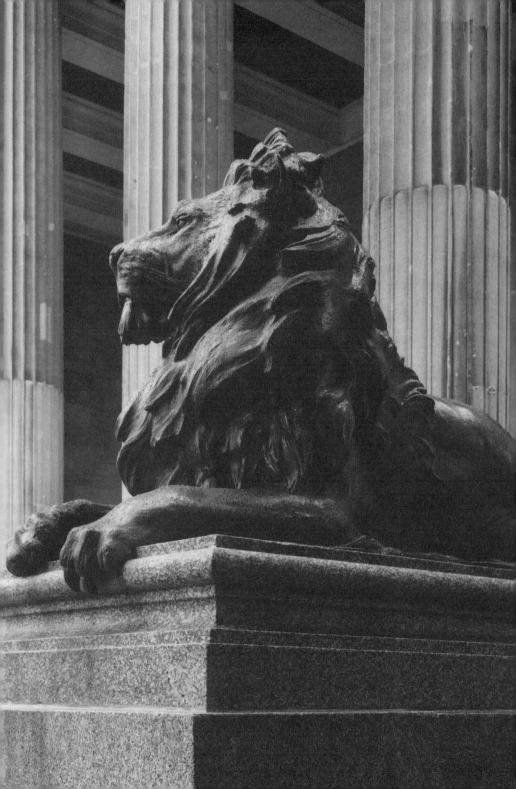

Edward VII statue (detail)
by Henry Poole & Rickards
bronze, 1736
Queen's Road
Bristol

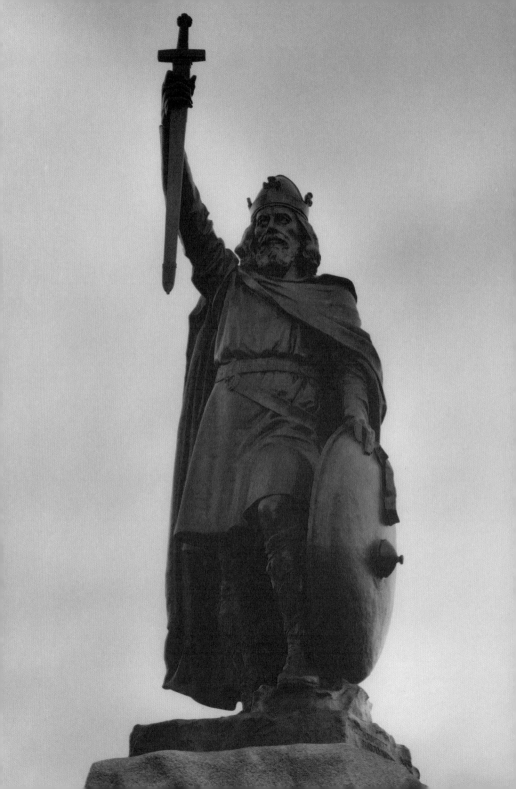

Alfred the Great
by Hamo Thornycroft
bronze, 1901
The Broadway
Winchester

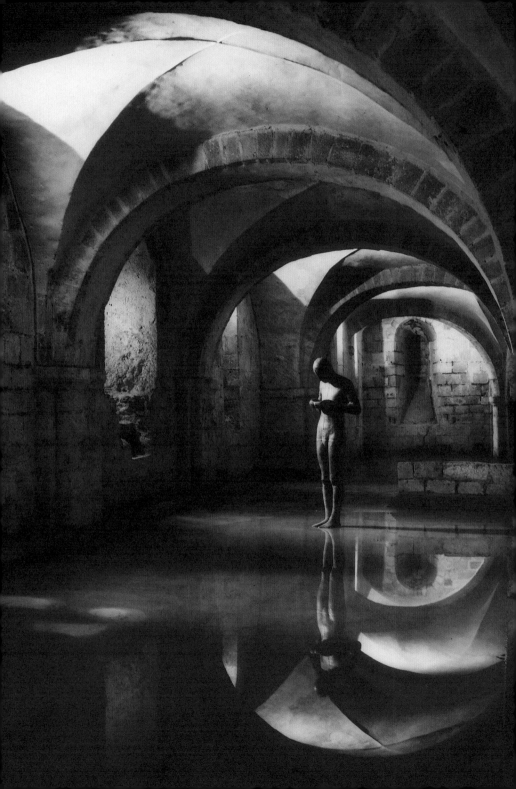

Sound II
by Antony Gormley
lead figure, installed in 1986
Winchester Cathedral Crypt

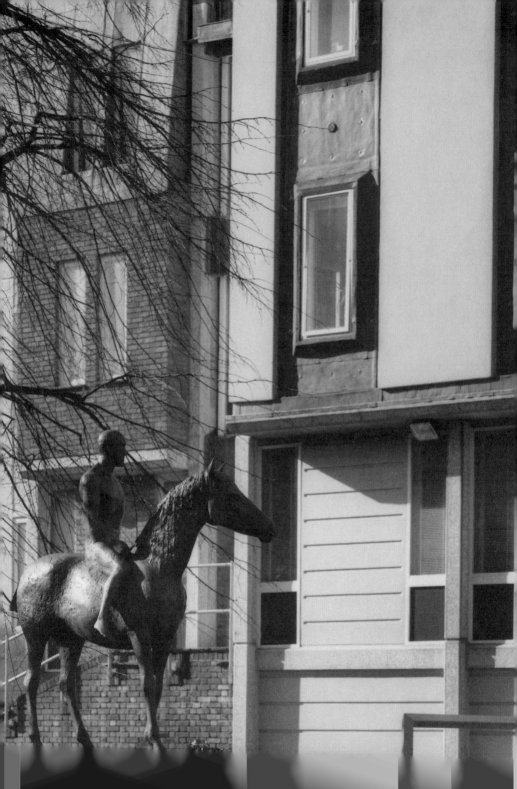

Horse and Rider
by Elisabeth Frink
bronze, 1980
High Street
Winchester

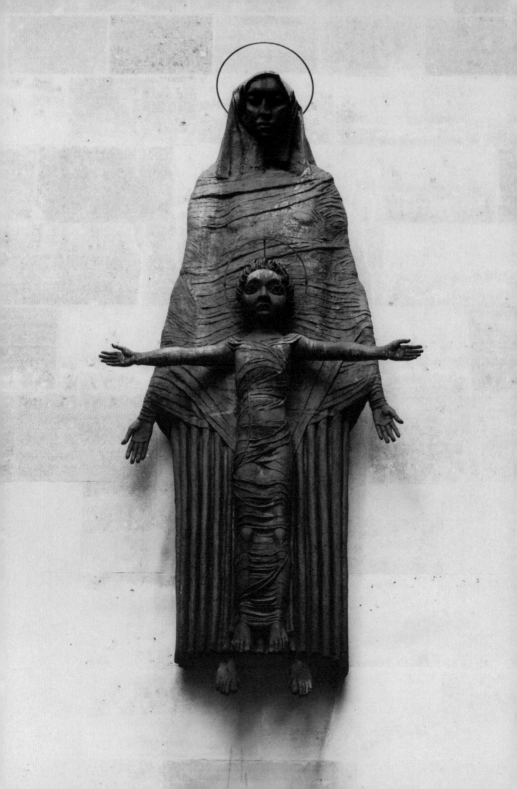

Madonna and Child
by Jacob Epstein
lead, 1952
north east edge of Cavendish Square
London

Head of Newton
by Eduardo Paolozzi
bronze, 1990
Butler's Wharf
London

MAP OF THE REGIONS

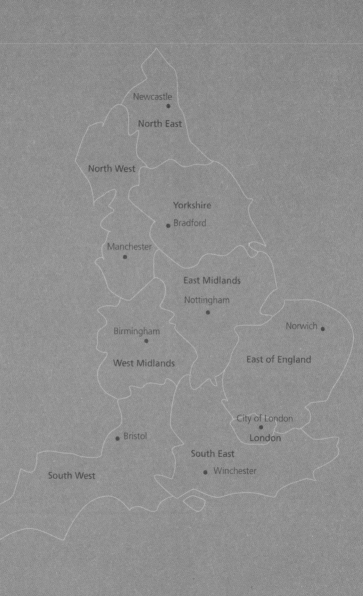

Newcastle
North East

North West

Yorkshire
Bradford

Manchester

East Midlands
Nottingham

Norwich

Birmingham

West Midlands

East of England

City of London
London

Bristol

South East

South West

Winchester

Introduction
The Newcastle Sculpture Walk starts at the top of the city and runs down to the Tyne. This more or less accords with the way that different phases of public sculpture in the city are distributed geographically. Very recent works tend to be on the Quayside, one of the longest-established parts of the city; older works tend to be further north. This is because, as happened in cities elsewhere, Newcastle 'rediscovered' its river only quite recently, in the 1980s, and subsequently has made considerable use of new public sculpture as a way of enhancing its various riverside regeneration schemes.

NORTH EAST

Amid a rich variety, works on the Walk give a good idea of the development of public sculpture in Britain in the last two centuries. In chronological terms, the earliest is 'Grey's Monument', the crowning glory of Richard Grainger's redevelopment of central Newcastle in the 1830s. After this come monuments to two local worthies, George Stephenson and William Armstrong, erected in the Victorian and Edwardian periods, and Alfred Gilbert's Queen Victoria (1903). These are followed by Thomas Eyre Macklin's South African War Memorial and Goscombe John's virtuoso work, The Response: 1914 - both dating from the early years of the 20th century.

Then comes David Wynne's River God Tyne, decorating the city's grandiose 1960s Civic Centre, a work which bears witness to the fact that traditional sculpture-making continued into the 1960s despite the use of new materials and approaches in avant-garde sculpture at the time. At the end of the walk are three pieces on the East Quayside from the late 1990s by Neil Talbot, Andrew Burton and Raf Fulcher, all commissioned by the Tyne and Wear Development Corporation. These are slightly more individual in subject-matter and style, but like the Wynne they can be seen as developments of, rather than challenges to, previous ways of making public sculpture.

Several of the works on the Walk are by locally-based artists. It cannot be claimed, however, that either in subject-matter or style these give evidence of what one might call a Newcastle tradition of sculpture-making.

NEWCASTLE SCULPTURE WALK

The walk starts at the Monument to Lord Armstrong, Barras Bridge, and ends at Swirle Pavilion, Quayside. About 1.5 miles.

1. Monument to Lord Armstrong (1810-1900)
by Hamo Thornycroft
Bronze statue with reliefs on screens to either side of plinth, 1906, Barras Bridge

The monument commemorates the local inventor and manufacturer who in the latter part of the 19th century transformed Newcastle into one of the leading industrial centres in the world. The two reliefs on either side of Armstrong's figure (in the company of his Scotch terrier) illustrate aspects of his various industrial concerns. One shows a hydraulic crane and sheerlegs lowering a 12-inch gun onto a battleship at the vast armaments and engineering plant at Elswick, the other a ship being towed through the Swing Bridge in the centre of Newcastle which Armstrong designed to allow large ships to pass up the Tyne. The location of the monument outside the Hancock Museum testifies to Armstrong's long involvement with the Newcastle Natural History Society and in particular to his generosity in 1882 when he gave £8,000 towards the cost of building the Museum.

2. The Response:1914
by William Goscombe John
Granite wall with a frieze of bronze high relief figures on one side and low relief carvings on the other, 1923, Barras Bridge

The memorial was the private gift of a local ship-owner, Sir George Renwick, who wished to commemorate three events: the raising of the Commercial Battalions of the Northumberland Fusiliers, the safe return of his five sons from the war and his own attainment of fifty years in commercial life. On its west, front, side is one of Goscombe John's most brilliant displays of virtuosity, a throng of men responding to Victory's call to arms, with Victory represented as a winged figure floating above their heads. Sympathetic observation (resolute drummer boys, men bidding

farewell to their wives and children) combines with a great sense of dynamic forward movement to make The Response, in the recent words of one writer, 'one of the finest sculptural ensembles on any British monument'.

3. River God Tyne
by David Wynne
Bronze figure attached to wall, 1968, Civic Centre entrance, Barras Bridge

This is one of several sculptural adornments to Newcastle's palatial Civic Centre (architect George Kenyon, 1960-68). The idea of a River God is taken from a detail on the façade of Somerset House in London (1768), which shows the 'head' of the River Tyne. A wooden version decorated a shop in Newcastle in the early 19th century. Wynne, however, changed this into a massive bronze figure who bends over to wash himself with water which, if the fountain in his raised hand were working, would trickle down his body. In recent years, unfortunately, the fountain has been reduced and the original effect lost.

4. South African War Memorial
by Thomas Eyre Macklin
Stone obelisk with bronze figure at the top and base and other bronze decorations, 1908, Haymarket Metro Station, Percy Street

The memorial commemorates the men of the Northumbrian regiments who lost their lives in South Africa. A twice-lifesize, semi-naked bronze figure of Northumbria is shown reaching up to receive the tribute of Victory, a winged bronze figure holding a sword on the top of the obelisk. There are various bronze shields and garlands attached to the obelisk as well as a relief panel with a naturalistically rendered scene of helmeted British soldiers storming a Boer-held kopje. In recent years the memorial has seen some

changes. In the mid-1970s the figure of Victory was fitted with fibreglass after it had been removed to prevent it from being damaged during construction of the nearby Metro station. Then in 1999 a water feature by the sculptor Ray Smith was erected at the base: comprising a series of concrete abstracted figures, this now partially obscures the memorial from the north and west.

5. Monument to Earl Grey (1764-1845)
Architect Benjamin Green
Sculptor Edward Hodges Baily
Doric column with stone statue, 1838, Blackett Street

The monument commemorates Charles, 2nd Earl Grey, the local landowner and Whig politician who as Prime Minister passed the Great Reform Bill in 1832. The fluted stone column and base rising somewhat abruptly from the ground is the work of a local architect, the twice-lifesize statue of Grey wearing court dress is that of the prolific London-based sculptor who slightly later, in 1839, was responsible for the figure of Nelson in Trafalgar Square. The head, dislodged by lightning in 1941, was replaced some years later by Roger Hedley.

The memorial was not universally liked at first. It was designed to be climbed (having 164 steps), which attracted visitors in the 19th century, and it has become a popular meeting-point since the area round the base was pedestrianised in 1983. It can still be climbed on some days.

The lengthy inscription on the dado detailing Grey's career was written by his friend, the Rev. Sidney Smith, and added in 1854. The inscription on the back claiming that the people wished to 'renew their gratitude to the author of the Great Reform Bill' was added in 1932 at the order of a group of local Liberal and Labour politicians who feared the spread of totalitarian ideas from the Continent.

6. George Stephenson (1781-1848)
by John Graham Lough
Bronze statue and supporters on a stone base,
1862, Westgate Road

The 'Father of Railways', George Stephenson, was born in the Newcastle area and worked there early in his career. This site was chosen partly so that workers en route to his son Robert's locomotive factory could glance up as they passed and see in his monument a lesson about the benefits of self help. The idea was perhaps particularly embodied in the way the pensive, Demosthenes-like figure above, and the part-Greek, part-contemporary railway plate-layer, blacksmith, locomotive engineer and miner at the base relate to one another.

The locally-born sculptor, John Graham Lough, based his design on his unsuccessful submission to the competition for the Nelson Monument in Trafalgar Square. It is a version of Bandinelli and Tacca's Monument to Ferdinand I in Livorno, Italy (1599-1623).

7. Queen Victoria (1819-1901)
by Alfred Gilbert
Bronze statue with canopy on granite plinth,
1903, outside St Nicholas's Cathedral, Mosely St

The statue was the gift of Sir William Stephenson, a local businessman and politician, commemorating the recently deceased queen and also the 500th anniversary in 1900 of the office of Sheriff in Newcastle. The figure of the diminutive queen nestling in the deeply-modelled folds of a huge, flowing cloak is a replica of Gilbert's 1887 Jubilee Monument in Winchester. The canopy above her throne, on the other hand, with its free, very personal arrangement of pediments, brackets and plinths, is completely original, a deliberate attempt to echo in shape the lantern of the steeple on the nearby cathedral.

To his embarrassment the renowned sculptor Alfred Gilbert did not complete the canopy on time, because bankruptcy in 1901 forced him into voluntary exile in Belgium (where the casting of both statue and canopy was done).

8. River Tyne
by Neil Talbot
Series of stone reliefs,1996, Quayside

Seventeen reliefs depict landmarks to be found along a thirty-mile stretch of the Tyne, starting with Cawfields Roman mile castle, Haltwhistle, on the Cumbrian border and ending with North Shields Fish Quay and Tynemouth Priory. They are carved directly into a 100 ft wall which follows the line of Newcastle's 14th-century Town Wall, demolished in 1763. Talbot, a locally-based sculptor, and his sister and son who assisted him, found themselves under constant scrutiny of a crowd of appreciative passers-by as they worked on the piece in the summer of 1996.

9. Rudder
by Andrew Burton
Bronze on a concrete base, 1996, Keelman Square, Quayside

A large, hollow, curving form is set into the work's base at a slight angle. In its personal evocation of the life and history of the Tyne it is similar to several pieces which the Tyne and Wear Development Corporation commissioned to enhance new developments on the East Quayside. The sculptor has spoken of it as being more successful than his Column and Steps which stands nearby.

10. Swirle Pavilion
by Raf Fulcher
Stone, metal and concrete folly, 1998, Quayside

At once a sculpture and a building, Fulcher's
pavilion comprises a circular chamber open to the
sky surmounted by a large gilded orb. Its theme,
'location and navigation', is announced by the
names of ports such as Hamburg, Genoa and
Aberdeen, which in former times were served by
the Tyne-Tees Steam Shipping Company, rendered
in gilt letters on the inner rim of the pavilion
ceiling. The work takes its name from the Swirle, a
stream which used to swirl out into the Tyne at the
point where it stands.

NEWCASTLE SCULPTURE WALK

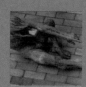

1. Monument to Lord Armstrong

2. The Response:1914

3. River God Tyne

4. South African War Memorial

5. Monument to Earl Grey

6. George Stephenson

7. Queen Victoria

8. River Tyne

9. Rudder

10. Swirle Pavilion

Around Newcastle and in Tyne and Wear there are notable commemorative pieces from the 19th century, for instance J.G. Lough's gargantuan Collingwood Monument at Tynemouth, the Parthenon-like Penshaw Monument and George Burn's pieta-like monument to the oarsman, James Renforth, outside the Shipley Art Gallery at Gateshead. However, the county is chiefly remarkable for its new sculpture - perhaps the greatest concentration of such work in the country. The most publicised is Antony Gormley's Angel of the North (1998), on the south approaches to Gateshead.

SCULPTURE IN THE REGION

There are, though, other large-scale pieces which should be noted: Juan Munoz's sack-like figures at South Shields, Mark Di Suvero's heroic Tyne Anew at North Shields and Alison Wilding's floating piece, Ambit, under the bridges in Sunderland. There are also interesting, more discreet works in more rural settings including pieces by Colin Rose, Andy Goldsworthy, Richard Deacon and Richard Harris on the Gateshead Riverside Sculpture Trail.

Outside Tyne and Wear, Northumberland has a number of striking older works. John Soane's Evelyn Column (1787) which used to be in Surrey now, improbably, stands on a hillside at Lemmington; David Stephenson's Percy Tenantry Column (1816) at Alnwick has Trafalgar Square-like lions at the base, and18th-century warrior figures appear on the battlements of Alnwick Castle.

County Durham has Raffaelle Monti's 1861 dashing equestrian statue of the Marquis of Londonderry in Hussar's uniform in Durham City as well as two large-scale modern pieces, Victor Pasmore's 1960s Apollo Pavilion at Peterlee, and Tony Cragg's steel theodolite and level, Terris Novalis, set up in 1997 outside Consett as part of a SusTrans (Sustainable Transport) cycle route. On the fringes of Darlington is the much-publicised 1997 brick replica of the Mallard steam locomotive by David Mach, and at Middlesbrough in the county of Cleveland, Claes Oldenburg's giant steel Bottle of Notes (1993) is the result of a collaboration between Oldenberg and his wife Coosje van Bruggen. It is based on the ship's log of Captain Cook, born at nearby Marton. Theirs, and other contemporary works join Middlesbrough's earlier commemorative sculptures, and this is characteristic of the North East.

Introduction

Manchester possesses one of the largest collections of public statues and monuments in any provincial British city. It includes examples of the work of some of the country's leading 19th- and early 20th-century sculptors. As in those other large towns that were the product of the industrial revolution, it was the 19th century which saw the erection of the largest number of outdoor statues. For much of the 20th century, apart from war memorials, there was a growing unease with the idea of commemorating individuals in stone and bronze.

NORTH WEST

It was only after the Second World War that the communal value and importance of public sculpture began to be reassessed, albeit slowly. In this movement the role of the local authority has been a distinguishing feature. But, today, in Manchester as elsewhere, attitudes to public statuary and sculpture remain ambivalent. What might be celebrated as an enormous outdoor art gallery or museum is ignored by many people.

This short walk invites you to stop and look more closely at ten sculptures sited in or close to Albert Square and St Ann's Square. Piccadilly Gardens, currently the subject of a redevelopment programme, contains a remarkable collection of statues (Sir Robert Peel, 1853; Duke of Wellington, 1856; James Watt, 1857; Queen Victoria, 1901) which would serve as the starting point for another walk. Although some of the statues will be relocated within the gardens, they will retain their historic context. Free to view, such monuments are defining elements in the city's public spaces, reference points which connect us to the ideals and values of the city. It is a walk through the past that stirs the imagination for the future.

MANCHESTER SCULPTURE WALK

The walk begins in Albert Square and ends at the South African War Memorial, St Ann's Square About 1 mile overall.

1. Albert Memorial
Architect Thomas Worthington,
Sculptor Matthew Noble
Marble statue of Albert, Prince Consort (1819-1861); stone ciborium, Albert Square, 1867

After considering a number of ideas, Manchester's tribute to Prince Albert took the form of a public memorial. Matthew Noble (1817-1876) sculpted the marble statue and the magnificent shrine-like canopy was the work of the Manchester architect, Thomas Worthington (1826-1909). The statue was the gift of Thomas Goadsby whilst the canopy was paid for by public subscription. The question of the site proved contentious and having failed to find a place in one of the city's more public spaces, the memorial was placed close to the Town Yard. Building began in 1863 and was completed in 1866.

Both the Queen and the Prime Minister declined invitations to open this particular Albert Memorial. But what had been an undistinguished site was to change in the following years, as a new town hall was built on the old Town Yard. Albert Square had begun its long transformation into the city's most important public space. The marble statue, on its polished granite plinth, is visible through the four open arches of the memorial. The rich carvings, figures and medallions on the canopy represent and symbolise interests of Prince Albert. Neglected for much of the 20th century, the memorial's architectural and historical significance is now recognised.

2. James Fraser (1818-1885)
by Thomas Woolner
Bronze statue on granite plinth,1888, in Albert Square (near Princess Street)

When James Fraser was appointed Manchester's second bishop in 1870 he was virtually unknown in the city; by the time of his death in 1885 he had

become its most popular clergyman. He was paid that rare tribute for a Victorian bishop of an outdoor public statue. A public subscription to erect a statue to the 'Bishop of All Denominations' soon collected over £3,000. Thomas Woolner (1825-1892), one of the Pre-Raphaelite Brotherhood, was commissioned to produce the statue. Woolner had previously sculpted the statues on the Manchester Assize Courts, which were destroyed in 1940s bombing; his sculptures were resited in the Crown Courts.

The site selected was on the edge of Albert Square, and Woolner decided to place Fraser looking towards the Cathedral rather than the Town Hall. The bronze statue depicts Fraser in his ordinary clothes, surmounting a granite plinth which is decorated with three bronze panels showing different aspects of his work in the diocese. Over the years, as other statues were placed in Albert Square, calls have been made to turn Fraser to face the Town Hall.

3. William Ewart Gladstone (1809-1898)
by Mario Raggi
Bronze statue on granite plinth, 1901, Albert Square (near Mount Street)

Following Gladstone's death in 1898 a number of towns decided to raise a statue to commemorate his achievements. Manchester's statue was unusual in that it was paid for by a single individual rather than by public subscription: William Roberts, a local architect and Liberal supporter, left money in his will to meet the costs of a statue. The sculptor was Mario Raggi (1821-1907), whose other public statues included one of Benjamin Disraeli in London's Parliament Square. Raggi's bronze statue, mounted on an ornate red granite plinth, depicts Gladstone in the act of addressing the House of Commons during a debate on Home Rule. It was said that passers-by, seeing Gladstone's figure with

its oustretched right arm, would ask: 'Which way to Central Station'?

John Morley, Gladstone's colleague and biographer, unveiled the statue with the usual ceremony and speeches that marked such civic occasions. This was Manchester's second statue to Gladstone, as the City Fathers had honoured him some twenty years before with a statue by William Theed in the Town Hall.

Proceed to the main entrance of the Town Hall to view the next two statues.

4. John Dalton (1766-1844)
by Francis Chantrey
Marble figure, 1839, main entrance of Manchester Town Hall

John Dalton, the Manchester chemist whose scientific discoveries included the theory of the atom, was the individual honoured in Manchester's first major public sculpture. It was commissioned during his lifetime from the country's leading sculptor, Sir Francis Chantrey (1781-1841). Dalton left a revealing account of his visit to sit for Chantrey. Dalton was shown in academic robes, a seated figure holding a book in his left hand, scientific apparatus at his feet. Paid for by public subscription, this 'beautiful and all but speaking statue' was originally displayed in the Royal Manchester Institution (now the City Art Gallery) on Mosley Street. It remained there until 1884 when it was moved to the Town Hall. A bronze copy, made by William Theed, was placed in Piccadilly, and later moved to Chester Street.

5. James Prescott Joule (1818-1889)
by Alfred Gilbert
Marble figure, 1893, Manchester Town Hall

The research conducted by the Salford-born physicist, James Prescott Joule was fundamental to the understanding of electricity and

thermodynamics - a contribution later recognised in the unit of energy which bears his name. In Manchester Joule's scientific work was honoured after his death by commissioning a marble sculpture from Alfred Gilbert (1854-1934), the most gifted of all late Victorian sculptors. The sculpture was to be placed in the Town Hall next to Chantrey's statue of Manchester's other great scientist and Joule's teacher, John Dalton. Characteristically, Gilbert chose to depict Joule not in formal dress but seated on a chair, wearing a large smoking jacket and slippers. He appears deep in thought, his left hand holding a scientific instrument. The statue was unveiled by Lord Kelvin. A further local memorial to Joule, by John Cassidy, was later erected in Worthington Park, Sale.

6. Abraham Lincoln (1809-1865)
by George Grey Barnard
Bronze statue on polished granite plinth, 1919, 1986, Lincoln Square

This huge bronze statue of Abraham Lincoln was the gift of two Americans, Mr and Mrs Charles Phelps Taft, and is a copy of one by George Grey Barnard (1863-1938) in their home town of Cincinnati, Ohio. It was originally intended that the statue should stand outside the Houses of Parliament, a symbol of the long friendship between the United States and the United Kingdom. But considerable controversy arose over what was seen as Barnard's clumsy depiction of Lincoln, resulting in the installation of the more statesmanlike statue of Lincoln by Augustus Saint-Gaudens.

The Barnard statue was subsequently presented to Manchester, where it was placed in Platt Fields on a stone plinth made short, so that Lincoln stood alongside the onlooker, and unveiled in 1919. The statue was transferred to the city centre in 1986 as the centrepiece of the new Lincoln Square. Edited

extracts of correspondence from Lincoln acknowledging the sacrifices made by Lancashire cotton workers during the Civil War can be read on the new, substantial polished granite plinth.

7. Doves of Peace
by Michael Lyons
Steel sculpture on concrete plinth, 1986, Albert Bridge

Doves of Peace was one of the first outdoor sculptures commissioned by the City Council in the 20th century. Its origins can be traced back to the decision in 1980 to establish Manchester as the world's first nuclear free city. As part of the council's policy to increase awareness of the issues involving nuclear power, it organised a 'Sculpture for Peace' competition. The winning sculpture was Barbara Pearson's Messengers of Peace which was installed in the newly created Peace Garden at the rear of the Town Hall. Michael Lyons' entry in the competition was short-listed and also commissioned. After considering a number of sites it was placed on the open space by Albert Bridge. The white painted steel sculpture represents doves with their wings entwined rising up into the sky. It is mounted on a white concrete plinth, around which the inscription proclaims Manchester to be the world's first nuclear free city.

8. Joseph Brotherton (1783-1857)
by Matthew Noble
Bronze sculpture on brick plinth, 1858, 1986, Riverside Walk

This large bronze statue of Joseph Brotherton was originally located in Peel Park, Salford, erected and paid for by the people of Salford to honour the memory of their first member of parliament. Brotherton commanded enormous respect in Salford where his energies had helped to establish a public library, museum and Peel Park. The statue

was one of a number that Matthew Noble (1817-1876) produced for the park during the Victorian period.

After the Second World War the Brotherton statue was taken down and subsequently sold by Salford Council to a private individual. In the 1980s Manchester City Council decided to purchase the statue and placed it in its present position, allowing Brotherton to look across the River Irwell at the city that had memorialised him in bronze. The modern plinth contains part of the original inscription acknowledging Salford's 'faithful representative'.

9. Richard Cobden (1804-1865)
by Marshall Wood
Bronze figure on granite plinth, 1867, St Ann's Square

Richard Cobden was one of the leaders of the Manchester-based Anti-Corn Law League which campaigned against the Corn Laws. When the Corn Laws were repealed in 1846 Cobden was recognised as one of the principal architects of a brilliant political campaign. He was fêted in Manchester as a hero. His later political views were less favourably received, but following his unexpected death in 1865 it was his role in ensuring cheaper bread that was remembered.

A proposal for a statue found immediate and widespread local support. The commission was given to Marshall Wood (d.1882) who had already produced a much praised bust of Cobden. Various sites were considered, including Piccadilly, before St Ann's Square was decided upon. The bronze statue depicts Cobden, dressed in long coat, in the act of public speaking. The statue was originally situated more centrally in the square but subsequently moved closer to the church.

10. South Africa War Memorial
by Hamo Thornycroft
Bronze sculpture on granite plinth, 1908, St Ann's Square

Subscriptions to erect what was to be Manchester's first major outdoor public war memorial began to be collected in 1902. It commemorates those who died in battle and of disease during the Boer War. The statue was the work of Hamo Thornycroft (1850-1925), a sculptor whose work was influenced by the New Sculpture movement, a reaction to the formality and stiffness of Victorian statuary. It shows a soldier from the Manchester Regiment, rifle in hand, in the act of defending a wounded comrade, and was based on an incident which occurred at Caesar's Camp, near Ladysmith.

The memorial was unveiled by General Sir Ian Hamilton in 1908. Some 340 names of the officers and men who lost their lives in the 'war in South Africa 1899-1902' are listed on the bronze panels on the plinth. Granite protectors at the base of each corner remain as a reminder of an earlier time when traffic filled the square.

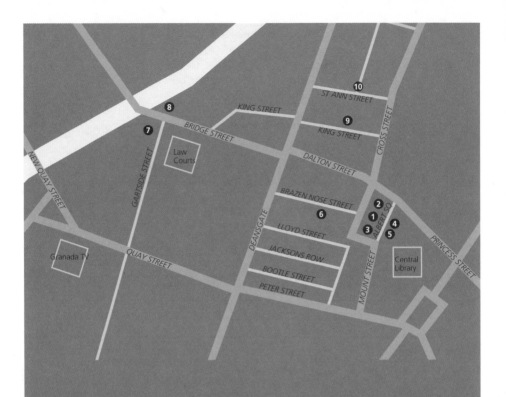

MANCHESTER SCULPTURE WALK

1. Albert Memorial

2. James Fraser

3. William Ewart Gladstone

4. John Dalton

5. James Prescott Joule

6. Abraham Lincoln

7. Doves of Peace

8. Joseph Brotherton

9. Richard Cobden

10. South African War Memorial

The North West's industrial towns, dating from the industrial revolution, are set in a region of farmland, seaside resorts, mountains and lakes. Public sculptures reflect these variations. County town statues, like Chester's bronze equestrian of 1st Viscount Combermere (Baron Marochetti, 1865), or Carlisle's 1st Earl of Lonsdale,1845 (by M.L. Watson, born in Lonsdale) represent landed families with long local pedigrees.

SCULPTURE IN THE REGION

On St Anne's seafront, a stone statue of a lifeboatman by William Burnie Rhind (1888) stands on a rocky pedestal. The stone carver Thomas Bland's sculpture garden at Reagill Farm, Lyvennet Vale in Cumbria, was spot-listed Grade II in 1999; Bland's monument to Queen Victoria (1842) stands on Shap Fell. A Forestry Commission 1970s sculpture trail features wood carvings in Grizedale Forest. At Friar's Crag on Derwent Water, a bronze relief of John Ruskin is set in a chunk of Borrowdale slate (sculptor A.C. Lucchesi, designer W.G. Collingwood, 1900).

Commercial and industrial centres all have 19th- or early 20th-century commemorative sculpture, principally of industrialists, benefactors or reformers, with large collections in Manchester and Liverpool; Greater Manchester alone contains some 400 significant pieces, in town centres like Bury (Sir Robert Peel by E.H. Baily, 1852), and Bolton which has bronzes of Samuel Chadwick (C.B. Birch, 1873), Sir Benjamin Dobson (J. Cassidy, 1900) and Samuel Crompton, 1862 by W. Calder Marshall whose sculpture enlivens the Town Hall façade. In Barrow-in-Furness, Cumbria, the industrialist and 'Father of the Town' Sir James Ramsden (Noble, 1872) stands outside the museum.

Statues were important features of public parks: Oldham's Alexandra Park statuary includes John Platt (D.W. Stevenson, 1878) and 'The Workers' Friend' solicitor Robert Ascroft by F.W. Pomeroy,* 1903; E. Gillick's statue of Frederick Sharp Powell, 1910 in Mesnes Park, Wigan reputedly brings luck to all who touch him, as his bronze-burnished shoe signifies.

Liverpool's growth in commerce and shipping brings a notable body of public sculptures from the late 19th and early 20th centuries, including the Duke of Wellington's statue on a Doric column

inaugurated 1863 (by brothers architect Andrew Lawson, and sculptor G.A. Lawson) and augmented by the city's monument to Lord Nelson designed by Matthew Cotes Wyatt, with sculpture by the elder Richard Westmacott (unveiled 1913). Westmacott's equestrian bronze of George III (based on Rome's statue of Marcus Aurelius) was erected In 1822. Architectural sculpture is abundant and includes Jacob Epstein's vigorous relief panels of ciment fondu (a quick-drying, aluminious cement) surmounted by the bronze, free-standing, Liverpool Resurgent, unveiled in 1956 on Lewis's Store. Liverpool's Anglican Cathedral, started by George Gilbert Scott in 1903, includes a noteworthy interior sculptural programme - the work of Liverpool sculptor Edward Carter Preston.

The city's equestrian monuments to Victoria and Albert, companion pieces outside St George's Hall, show Victoria in youth (as at Salford, which has companion marbles by Noble). Both are by Thomas Thornycroft, 1869 and 1866 respectively. Behind the Hall St John's Gardens, opened 1904, accommodate commemorative sculptures of Liverpool benefactors including F.W. Pomeroy's 1905 monument to the social reformer Monsignor James Nugent, and George Frampton's 1899 bronze to Sir William Rathbone - 'a guardian of the poor in Liverpool', as inscribed on the pedestal. At the centre is the King's Liverpool Regiment memorial, with bronze sculptures signed by W. Goscombe John, 1905, below the foot of The Drummer Boy. On St George's Plateau between Victoria and Albert is a period piece unveiled in 1930, the First World War Cenotaph by the architect Lionel Budden. The big bronze relief panels are by G.H. Tyson Smith who, like Budden, was Liverpool trained and based. His work can be seen throughout the locality.

In many north-west towns it is the war memorials that display outstanding examples of sculpture: a visit to Ashton-under-Lyne (Howard and Floyd, 1922), and St Anne's with sculptures by W. Marsden, might serve as an introduction. Nor should the smaller town memorials such as those at Crompton (R.R. Goulden, 1923) and Chadderton (A. Toft, 1921), Greater Manchester, be overlooked. Notable also are monuments to Queen Victoria in later age, Manchester's monumental bronze by Onslow Ford, 1901, and St Helens's by George Frampton (1906) being among the most opulent. Frampton's is currently the subject of a ground-breaking sculpture conservation programme set up by Liverpool City Council with conservators of National Museums and Galleries on Merseyside. Lancaster's 1906 statue by Herbert Dalton has a bronze pantheon of the great and good in high relief around its base.

In a region having its share of the odd and the exceptional, Cheshire's carved memorial tower to Mrs Gaskell at her birthplace, Knutsford, deserves mention. Near Nantwich, and visible from the road are companion statues of Sir John Brunner (Goscombe John, 1919) and Ludwig Mond (Edouard Lantéri, 1910) outside the Winnington Research Laboratories, birthplace of ICI.

Much modern sculpture appeared in the 1980s and 1990s. Sculptures on the UMIST campus in central Manchester - Technology Arch (A. Wolkenhauer, 1989); Archimedes (T. Dagnall, 1990); Vimto (K. Morrison, 1992) and The Generation of Possibilities (P. Lewthwaite, 1999) - deserve the compliment of imitation.

The open-air sculpture project, artranspennine98, which had its western base at Tate Gallery Liverpool, provided The Text Garden: A Composition in Time (Douglas and Hodgson), now tended by the city council. Other sculptures straddle the Pennines from here to Hull in East Yorkshire.

The ambitious Irwell Sculpture Trail with some 30 works, including Tilted Vase (E. Allington, 1998), Stone Cycle (J. Edwards, 1997) and Stone Sculptures (U. Ruckriem, 1998), continues to expand, confirming the region as one that can present modern sculpture in forms and locations that will make people stop and look.

Introduction

With Bradford's 19th-century industrial wealth came a cultural awakening and a desire to go one better than other Yorkshire towns and cities. Resulting sculpture can be seen in the celebration of local worthies, national figures and individuals giving themselves a slice of architectural immortality.

YORKSHIRE

Like many major cities, new traffic and building layouts have led to sculpture being resited outside the centre. Sir Titus Salt was moved from outside the Town Hall (now the City Hall) to Lister Park. Sculpted in Carrara marble by John Adams Acton, he sits at the Norman Arch under his Gothic canopy designed by Lockwood and Mawson, carved by Farmer and Brindley. Also in Lister Park resides Samuel Cunliffe Lister in white Sicilian marble by Matthew Noble, the pedestal incorporating four bronze relief panels. A copy of Giambolognia's Diana stands in front of Cartwright Hall Art Gallery, with architectural sculpture by Alfred Broadbent.

Originally in Peel Place (renamed Petersgate), a bronze of Sir Robert Peel - ironically Bradford's first public sculpture - now stands in Peel Park on a Bramley stone plinth. Carved stone figures of Autumn and Spring given by Bradford's Band of Hope Union stand nearby.

Back in the City, architectural sculpture by James Tolmie (d. 1866) can be seen on the Wool Exchange adorned with thirteen portrait roundels ranging from Robert Stephenson to Christopher Columbus, with Bishop Blaise (patron saint of wool combers) and Edward IV over the entrance. Unity Hall boasts a portrait of Friedrich Von Schiller, and the Yorkshire Penny Bank medallions of the founder members. The Merchants' Quarter (Little Germany) displays private merchants' symbols, such as keystone faces or animals and ornate door mantels.

Bradford's Cathedral of St Peter harmonises its ancient foundations with a 1951-65 extension. Majestis by Alan Collins is on the new south chancel. Inside contemporary sculpture by Collins, David Hardy, Raymond Perkins, John Shaw and Vernon Hill harmonise with a memorial tablet to Joseph Priestley by William Pistill (fl. 1814-1844) and a relief monument to Abraham Balme by John Flaxman (1755-1826).

Other contemporary works range from Terry Hamill's rising geometric sandstone figure and Charles Quick's Lap Light in Little Germany to Ian Randall's illuminating Fibres in St Blaise Square, and Tim Head's Camera Lucida outside the National Museum of Film Photography and Television. There is a Mermaid by Ian Taylor on a roundabout. The Ivegate Arch of wrought iron, with panels depicting Bradford trades, stands at one of the old entrances to Bradford. Pavement poems, selected from school children's work by the late Poet Laureate Ted Hughes, were cut into sandstone in 1987. Currently controversial is the fibre-optic Needle, commissioned by Crysallis Arts for installation in March 2000.

On the outskirts of Bradford is Saltaire, the model village build by Sir Titus Salt. Here he stands immortalised in bronze by Francis Derwent Wood on a plinth with bronze panels, one of an alpaca (incorrectly inscribed 'goat'). Four lions outside the school by Thomas Milnes were reputedly made for Nelson's Column and a bust of Salt by Milnes is in the Congregational Church.

BRADFORD SCULPTURE WALK

The walk starts at Bradford City Hall, Bridge Street, and ends at the statue of Richard Oastler in Northgate. It is uphill; about 1.5 hrs' relaxed walk.

1. Thirty-five Stone Monarchs

Architects: Lockwood & Mawson, 1873,
stonecarvers: Farmer & Brindley
Architectural sculptures, Cliffe Wood stone, 1873,
Bradford City Hall. Bridge Street

The quality of the Gothic style City Hall is enhanced by thirty-five 7 ft sculpted figures of British monarchs. Each figure is carved in immense detail from a single block of local Cliffe Wood Quarry stone. The Monarchs follow in chronological order beginning at Bridge Street with William I and ending with Henry VIII. Elizabeth I and Victoria stand either side of the main entrance, and interestingly, Oliver Cromwell is included in the sequence. Each figure costing £63 was carved using a full-sized plaster cast model and displayed in the Town Hall, as it was then, with admission by fee, before being placed on the third floor arcade. The modern extension to the hall by Norman Shaw, 1908, was built as a result of receiving of City Status in 1897.

Inside City Hall in the Norman Shaw banqueting hall is a fine allegorical over-mantle frieze by C.R. Millar of Earp Millar and Hobbs. In New Sculptural form, figures symbolise industry and trade illustrating Bradford's motto, 'Labour Conquers All Things'.

2. Bradford Fire Disaster Memorial 11 May 1985

by Joachim Reisner,
Bronze, 1986, Centenary Square

The memorial to those who died in the tragic fire at Bradford City Football Ground takes the form of three ethereal bonze figures symbolising the divide between life and death moving in a broken circle to denote the damaged stadium. They stand on a plinth with support pillars by stonemason Rainer Wohrle and steps made from local Bolton Wood stone. The height of only 4ft, seemingly dwarfed by the magnitude of the disaster, was deliberately

designed so that children could read the names of the fifty who died and understand the significance.

Maquettes for the figures are displayed in the City Library and a Westmoreland Slate Memorial by John Shaw is in the Cathedral.

Follow the signs for the Alhambra Theatre across Princes Way.

3. Queen Victoria (1837-1901)
by Alfred Drury
architectural design by J. W. Simpson, stone lions by Alfred Broadbent
Bronze statue, 1904, near the Alhambra

Queen Victoria stands 12ft high, cast from three tons of bronze at a cost of £3,050 by J.W. Singer & Sons of Frome. She was unveiled by the Prince of Wales, later George V, in May 1904. Alfred Drury who had a number of Bradford patrons was the chosen sculptor. The plinth, balustrade and lions were an integral part of the design and were the work of J. W. Simpson, and Shipley sculptor Alfred Broadbent. Standing in her Jubilee robes of 1887, Queen Victoria wears a crown and wreath symbolising her status as Empress of India. English and Yorkshire roses, Scottish thistles and Irish Shamrocks are modelled at the base of her robe. She holds a sceptre and orb surmounted by a winged figure of Peace (or Victory).

4. First World War Memorial
by Walter Williamson (City Architect)
Bronze and Bolton Woods Quarry stone, 1922, near the statue of Queen Victoria

The War Memorial stands in the form of a cenotaph of locally quarried stone carved with a cross symbolising 'sacrifice', a wreath containing the words, 'Pro Patria Mori' (They died for their country) and the words 'Their Name Liveth for Evermore'. Two bronze figures of a soldier and sailor lunge forward with their rifles extended.

The rifles originally had bayonets, but as widely reported in the local press, these were considered too aggressive and were subsequently removed in the late 1960s when the Memorial was cleaned. The Memorial was unveiled on 1 July 1922, the 6th anniversary of the Battle of the Somme, when the Bradford 'Pals' Battalion of the West Yorkshire Regiment lost 37,000 men.

5. John Boynton Priestley (1894-1984)
by Ian Judd
Bronze statue on granite plinth, 1986, City Library

Priestley's over-lifesize figure stands stoically on a prominent site overlooking Bradford and dominating the viewer. Ian Judd said of this work, 'All I had heard about J.B. Priestley seemed to point to a rather difficult gentleman, but reading his books convinced me otherwise. Those who knew him described a shy humorous and amiable character who nonetheless wasn't afraid to speak his mind. It was this Priestley I wanted to convey'. True to this observation, Judd conveys the impression of a strong imposing figure, true to his beliefs who only accepted two of the many honours offered: the freedom of Bradford City in 1973 and the Order of Merit in 1977. Priestley stands on an enormous granite plinth with a bronze plaque giving a quotation from his novel *Bright Day* where the city 'Bruddersford' is based on Bradford.

6. Homage to Delius
by Amber Hiscott
Steel and coloured glass, 1993, Crown Courts

Of German descent, Frederick Delius (1862-1934) was Bradford-born. For much of his career he worked in France, but Bradford has never forgotten its most famous composer. A national competition was set up asking sculptors to create a focal point for the new Exchange Square. Amber

Hiscott, a Swansea artist, won the competition, and created her Homage to Delius in the form of two giant steel skeletal leaves with the coloured glass symbolising life still existing and giving the work light and texture. The leaves create a 20ft long tunnel which can be entered by the viewer. The inspiration for the work was derived from Delius's love of nature, and the themes of life, death and regeneration which occur in his music. Naturally, at a cost of £36,000 this work was never far from controversy, but it has now become an important part of the cityscape.

7. Grandad's Clock and Chair
by Timothy Shutter
Sandstone sculpture, 1992, Chapel Street

This sculpture has become synonymous with Little Germany and Bradford. On the sloping street, a mill-owner's office is recreated in the form of an over-lifesize comfortable chair, mirror and grandfather clock. The work looks back to the past when this area was the Merchants' Quarter, but the swinging pendulum implies that time moves on and although the past has its contribution to make, the future must take the form of regenerating the City. Timothy Shutter's sculpture was the winning design in a competition set up by Bradford City Council and the Little Germany Action Group in 1991. The work is quirky, full of character and entirely suited to the Italianate style warehouses with their own idiosyncratic symbols.

8. William Edward Forster (1818-1886)
by James Havard Thomas
Bronze statue, 1890, Forster Square

Forster was the Liberal MP for Bradford for twenty-five years, from 1861 until his death. Born in Dorset, he arrived in Bradford in 1841 and became a partner with William Fison in a woollen manufacturing business. Forster was committed to change and was largely responsible for the 1870 Education Act (the first national education act in this country) and the Ballot Act of 1872. The sculptor, James Havard Thomas, had many wealthy Bradford patrons who undoubtedly helped him receive this commission. Part of the New Sculpture movement, Thomas trained in London and Paris, but mainly lived in Italy where this 2-ton bronze of Forster was conceived and executed. Forster is depicted as a grand parliamentary orator, a Bradfordian making a declaration to the people of the City.

9. Richard Cobden (1804-1865)
by Timothy Butler
Bronze statue on red granite plinth, 1877, Wool Exchange, Market Street

Go inside the Wood Exchange to find Richard Cobden standing as if speaking to Parliament to convince them that the Corn Laws were economically disastrous, morally wrong and should be repealed. Cobden was the MP for the West Riding of Yorkshire from 1847 to 1857 and saw at first hand the effects and hardships of the Corn Laws. He was instrumental in converting Sir Robert Peel to a Free Trade policy. The sculptor, Timothy Butler, trained at the Royal Academy schools and was a constant exhibitor there, mainly of portrait busts; this full-length figure was therefore a major commission. On the granite plinth, a motto reads 'Free Trade, Peace and Goodwill among Nations'.

The statue was the gift of the wealthy American partner, George Henry Booth (of Firth Booth & Co, Stuff Merchants) as a measure of thanks to Bradford for his prosperity.

10. Richard Oastler (1779-1861)

by John Birnie Philip

Bronze statue on pink granite plinth, 1869,

Northgate

This memorial to Oastler, 'the Factory King', was the result of a national subscription. Most donations, however, came from Bradford and this, with Oastler's close Yorkshire connections, led to Bradford being considered the most worthy site for the monument. Oastler campaigned ceaselessly and to the detriment of his own health to reduce long factory hours in the mills, and to increase small wages for children.

Birnie Philip his sculptor, true to Oastler's ideals, depicts an humanitarian figure appealing to the viewer to look at a boy and girl in simple clothes and clogs. The statue was cast from 3 tons of bronze at a cost of £1500, at the foundary of H. Prince & Co. in Southwark. It was unveiled by the great Parliamentary reformer Lord Shaftesbury, himself commemorated (by The Shaftesbury Memorial otherwise known as 'Eros' in London's Piccadilly Circus) through his efforts to improve working conditions for the poor and for children.

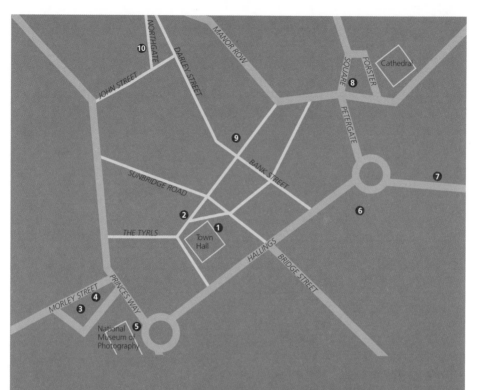

BRADFORD SCULPTURE WALK

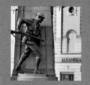

1. Thirty-five Stone Monarchs
2. Bradford Fire Disaster Memorial
3. Queen Victoria
4. First World War Memorial
5. John Boynton Priestley
6. Homage to Delius
7. Grandad's Clock and Chair
8. William Edward Forster
9. Richard Cobden
10. Richard Oastler

Yorkshire in sculptural terms is as rich and varied as any region. Cities of the West Yorkshire industrial conurbation show good examples of 19th-century and early 20th-century monumental bronzes, Leeds City Square retaining a great turn-of-the-century sculpture scheme with Thomas Brock's equestrian 'Black Prince' at the centre, accompanied by four local heroes by leading sculptors of the day, and a group of lamp-bearing female nudes by Alfred Drury. The city has other Victorian sculptures (some banished to Woodhouse Moore), and a growing number of contemporary sculptures.

Yorkshire's contemporary initiatives focus particularly on the Henry Moore Centre for the study of Sculpture at Leeds, with its continuous exhibitions, publications and events. The ambitious end of 20th-century commissioning project, artranspennine98, had its eastern base here. Some sculptures remain in situ across-country whilst temporary and resited installations are recorded in the Centre's archives.

Further on in West Yorkshire, Wakefield shows Henry Moores and Barbara Hepworths; Charles Quick's Light Wave on the station is a landmark, as is the design of the Cathedral precinct by Tess Jaray - a recent example of planning and design emanating from one artist. Featherstone Gardens contains work by Julia Barton, and the Yorkshire Sculpture Park at Bretton has a changing programme as well as permanent work by Hepworth, Moore, Frink and others. The Kirklees Way has sculptural waymarkers along a 75-mile walk.

SCULPTURE IN THE REGION

York's historic townscape has relatively little Victorian commemorative sculpture: there are marble statues of William Etty and George Leeman by the 19th-century York sculptor G.W. Milman, but otherwise contemporary work seems predominant. The University has an Austin Wright and a Hepworth, the Rowntree-Foss Islands-Osbaldwick SusTrans route near York has 'Big Blue Pipe' by George Cutt: start at the village of Bishopthorpe for SusTrans's 'Cycle the Solar System'. SusTrans (for 'sustainable transport') is a project to create cycleways with sculptured waymarks across Britain. Alain Ayres's large-scale inscribed stone oak leaves, set into the ground, begin further north at Masham, following the rivers Ure and Burn.

North Yorkshire market towns honour local worthies: the 2nd Lord Feversham seated under a Gothic canopy in the Market Square, Helmsley; the 1st Marquis of Ripon in Garter robes, in the city's Spa Gardens (F. Derwent Wood, bronze, 1912). Ripon's market place obelisk (1702), the earliest surviving in England, was quarried at nearby Studley Royal, estate of the Aislabies who laid out the grounds of Fountains Abbey with temples and classical sculptures.

Yorkshire's share of great houses have their monuments and sculptures: Castle Howard near Malton recently embarked on a conservation programme for its 18th-century lead figures, and at Harewood near Leeds, filling the entrance hall, is Jacob Epstein's 'Adam' carved from a massive block of alabaster.

The East coast enjoys two long walks with markers by Vivien Mousdell along the Cleveland Way and Wolds Way. Bridlington has promenade paving schemes by Christopher Tipping. Moving into East Yorkshire, Normanby Park has a sculpture trail and the estate village of Sledmere two unique First World War memorials, Queen Eleanor's Cross by Tatton Sykes and the Waggoner's Memorial designed by Mark Sykes (who raised the regiment) with sculptures by Carlo Magnoni.

Hull boasts a gilded lead William III on horseback by Peter Scheemakers. A statue of William Wilberforce is raised above the city on a Doric column, and he is commemorated in the Wilberforce museum courtyard by William Day Keyworth. Idiosyncratic is Harry Ibbetson's Amy Johnson in flying gear, Gordon Young's Fish Pavement Trail and Hull Marina Trail 1984-96.

In South Yorkshire, Sheffield Town Hall has E. W. Pomeroy's stone carvings and the Trades relief frieze by Alfred and Frank Tory. In the city are Alfred Drury's statue of Edward VII, David Wynne's 'Horse and Rider', and other sculptures from varying periods: Upper Chapel Court has three 1950s figurative sculptures by George Fullard. The Stone City Symposium, 1995, brought five interesting works whilst sculptures in steel, or commemorating steel, include the spider's web made of stainless steel sheeting and wire by Johnny White, 1995, for Gripples Ltd at the Old West Gun Works.

The mining industry leaves its mark with Graham Ibbeson's Conisborough memorial to all those killed in the industry, and his Barnsley memorial to those who died in the 1945 strike. In contrast, by the roadside at nearby Kendray, a classical winged figure marks the Oaks Colliery explosion of 1866. Barnsley and its part-mining, part-rural landscape lie beyond.

Introduction

This sculpture walk covers some of the main civic squares in Birmingham and gives just a flavour of the almost 400 sculptural works spread across the city, from commemorative figures to modern abstract works, architectural sculpture, and sculptural shop and pub signs. These public sculptures reflect the changing face of Birmingham, from market town to industrial city to modern cosmopolitan city brimming with ethnic and cultural diversity.

WEST MIDLANDS

By the middle of the 18th century Birmingham was an important manufacturing and industrial centre. In 1889, when Birmingham was granted city status, over a thousand trades were practised within the city which, with the surrounding region, was known as the 'workshop of the world'. This prosperity and self-confidence is visible in the 19th-century sculptures, starting with the first publicly-funded memorial statue in Birmingham, the Nelson Memorial of 1809 by Sir Richard Westmacott (1747-1809) in the Bull Ring, and including the terracotta façade of the Victoria Law Courts, 1887-91, by Aston Webb in Corporation Street. In 1885 the Birmingham Daily Mail claimed for Birmingham's growing number of statues 'they are monuments, not only of men, but of the material and moral progress of the town'.

Birmingham has an unbroken tradition of local production of public sculpture from the 18th century to the middle of the 20th century. Starting with the work of Edward Grubb (1740-1816), and encompassing the workshops of William Hollins (1763-1843) and his son Peter (1800-86), this tradition became closely aligned with the Municipal School of Art from the late 19th century (now part of the University of Central England). Both Benjamin Creswick (1853-1946) and William Bloye (1890-1975) trained and taught at the School, and there are many examples of their work and that of their students in the city.

Whilst the tradition of local production may have waned from the 1960s the recent interest in both public art and urban regeneration has renewed the vigour of public sculptures in the city. The beginning of the 1990s saw the start of a programme of revitalisation of Birmingham's inner city spaces, and sculptures and art works were seen as intrinsic to this process. This has resulted in one of the country's most ambitious and successfully-realised city public sculpture initiatives of the late 20th century.

BIRMINGHAM SCULPTURE WALK

The walk begins at Queen Victoria's statue, Victoria Square, and ends at the Boulton, Watt & Murdoch statue outside Registry Office, Broad Street. Less than 1 mile.

1. Queen Victoria (1819-1901)

Copy by William Bloye
from the original by Thomas Brock
Bronze statue on a granite plinth, 1901, 1951,
Victoria Square

Mr Barber, a local solicitor, presented this statue to Birmingham to commemorate the 1897 Diamond Jubilee of Queen Victoria and it was unveiled just days before her death in 1901. This is not Brock's original statue, which was of white marble and stood on a plinth of dark Cornish granite. As the marble had weathered badly, William Bloye reproduced it in bronze in 1951. It was erected on a plinth of lighter-coloured granite, thus reversing the original colour contrast of sculpture and base. Based on his earlier statue of Victoria in Worcester, here Brock has made the Queen's rather diminutive figure more monumental and imposing by exaggerating the length of the state robes.

2. Council House

Britannia and Supporters, Architect Yeoville Thomason; sculptors Richard Lockwood Boulton & Sons. Portland stone sculptural group, 1874-79, on the central pediment of Council House, Victoria Square

Behind Queen Victoria's figure stands the richly decorated Council House. Five of its triangular pediments are embellished with allegorical sculpture groups showing symbolic representations of civic virtue and pride. The central and most important pediment shows Britannia and Supporters.

Within the triangular compositional space all seven statues in the group are freestanding and carved fully in the round. The figure of Britannia is the largest and dominates those on either side with her arms stretched over their heads. The two figures standing next to Britannia represent the factory owners; the others are workmen who

operate tools and display the types of goods then made in Birmingham. The grouping of figures seems to represent a social hierarchy. It is only over the heads of the factory owners that Britannia holds the laurel wreaths, a symbol of victory and honour given to champions and heads of state.

3. Iron:Man
by Antony Gormley
Iron sculpture, 1992, Victoria Square

Down the slope and contrasting with the 19th-century works is Antony Gormley's Iron:Man, commissioned in 1991 by the TSB Bank and donated to the city. A full-length figure with its feet buried under the pavement and a faceless head, the figure is monumental and enigmatic, suggesting both a rise and a fall. Often interpreted as reflecting the alienation of the individual in modern society, it was intended to celebrate the traditions of Birmingham's industrial past, its workers and materials. Gormley originally called the work '"Untitled" until such time as usage give it one'. He renamed it Iron:Man after this title was adopted within the city.

4. River, Youth, Guardians and Object (Variations)
by Dhruva Mistry
Bronze fountain sculptures within Wattscliff lilac sandstone pools and sandstone sculptures, 1993, Victoria Square

The focal point of Victoria Square is the monumental female figure of The River, rapidly nicknamed The Floozie in the Jacuzzi by the local press. This river goddess sends water cascading down to the two figures of Youth in the lower pool. Bettina Furnee has carved a quote from T.S. Eliot's Burnt Norton on the rim of the upper pool. This gives a cryptic explanation in which the water represents a cycle of sunlight and life.

Two Guardians flank the lower level, large mythical beasts with human heads and animal bodies. One is a more masculine figure; the other is more female. Their title is a play on 'to regard' and 'to guard', as they simultaneously protect the site and gaze out across the city beyond. Defining the boundaries of the overall scheme are two sandstone pillars titled Object (Variations). Although they are abstract, elements of lighthouses, pagodas, Mexican pyramids, or even temples can be seen in their architectural details.

5. Chamberlain Memorial Fountain
Designer John Henry Chamberlain; portrait sculptor Thomas Woolner
Portland stone fountain with gilded mosaic, glass and copper details, 1880, Chamberlain Square

Around the corner from The River and the Council House, Chamberlain Square is dominated by the Chamberlain Memorial Fountain, erected to Joseph Chamberlain (1836-1914) by public subscription in gratitude for his services to the town as Mayor between 1873 and 1876. As Chamberlain had promoted the provision of a clean water supply in Birmingham, a fountain was considered the most suitable form of memorial.

The fountain is in Neo-Gothic style. Its spire-like form is that of a ciborium, or canopy, filled with tracery and decorative details, including mosaics of water-loving plants. The south side incorporates a portrait medallion of Joseph Chamberlain by Thomas Woolner, an early member of the Pre-Raphaelite Brotherhood. In 1880 the fountain was described in The Dart, a local newspaper, as 'an architectural scarecrow' and more recently Nikolaus Pevsner, in his Buildings of England series, dismissed it as an 'ungainly combination of shapes', but it is a satisfying example of the monuments of this period.

6. Thomas Attwood (1783-1856)

by Sioban Coppinger and Fiona Peever
Bronze seated statue with reinforced reconstituted
stone sculpture, 1993, on steps of Chamberlain
Square

Seated on the steps is this statue of Thomas
Attwood, one of Birmingham's first Members of
Parliament, who achieved renown for
Parliamentary reform. On three steps are bronze
papers, on each of which is a slogan reflecting his
views, while behind him is his soapbox.

In contrast to the square's other statues
commemorating men of Birmingham, Joseph
Priestley and James Watt, this piece is a consciously
non-heroic statement. Attwood reclines casually,
the soapbox acting as a reminder of a traditional
plinth. Reflecting the attitudes of the late 20th
century, Coppinger and Peever's Attwood is a man
of the people, sharing our space instead of being
placed on a plinth for us to look up to.

7. Industry and Genius

Monument to John Baskerville (1706-1775)
by David Patten
Portland stone and bronze sculpture, 1990,
Centenary Square

At the northern end of Centenary Square
(approached through Paradise Forum) are the eight
blocks of David Patten's Monument to John
Baskerville. These are centrally placed to reflect
both the portico of Baskerville House and the Hall
of Memory, with its allegorical statues of the
Armed Services by Albert Toft, which was erected
to commemorate the deaths of 12,320
Birmingham citizens during the Great War of
1914-18.

The title of Patten's work, Industry and Genius, is
taken from a poem in the Birmingham Gazette of
1751 dedicated to John Baskerville, the renowned
18th-century printer who had his works near this
site. Reversed bronze letters are applied to each
block, forming type-punches in his Baskerville
typeface. They form the word 'Virgil', because a
translation of Virgil's poetry was the first work to
be printed in Baskerville (in 1757).

8. Spirit of Enterprise

by Tom Lomax
Bronze fountain, 1991, Centenary Square

Further into Centenary Square, this fountain acts as
an allegory of modern multicultural Birmingham,
representing different heads cast from bronze.
Each head is ringed by a dish; these circular forms
and the flowing water symbolise eternity. The first
head (which faces the Hall of Memory) signifies
Industry with a vice and coin. The second head
(walking anti-clockwise) shows Enterprise leaping
from its bowl in hope and riding on a wave of
water thrown behind it. The head of Commerce
(facing the International Convention Centre) has
hands made of wire gesturing in an act of giving
and an open ledger behind it. Water anoints the
head with prosperity.

9. Forward

by Raymond Mason
Sculpture, fibreglass painted with polyester resin,
1991, Centenary Square

The commanding presence in the centre of the
square is Forward, depicting the people of
Birmingham past and present, striding into the
future with confidence. The main figure at the
front has his hand folded across his chest to signify
Birmingham as the Heart of England. Behind him,
a woman personifying Art from the City's Coat of
Arms throws a kiss to the past. Each character is

based on historical figures; for example the one
with the monocle is Joseph Chamberlain.
This sculpture has attracted much critical and
public indignation. This is only partly due to its
cartoon-like appearance, which does seem to
encourage children to use it as a climbing-frame.
The main complaint is the use of modern polyester
resin and fibreglass rather than more traditional
bronze or stone. It has been variously described as
being made of marzipan or margarine.

10. Boulton, Watt and Murdoch
by William Bloye
Bronze figurative group on a stone plinth, 1956,
outside the Registry Office, Broad Street

Across the road from Centenary Square is this
statue of three men in 18th-century costume,
nicknamed 'The Carpet Salesmen'. As the
inscription records, it commemorates the 'immense
contribution to the industry of Birmingham and the
world' of three local industrialists. These imposing
over-lifesize figures are the manufacturer Matthew
Boulton (1728-1809) and engineer William
Murdoch (1754-1839), with the engineer James
Watt (1736-1819) directing the discussion on the
right. The grouping conveys the teamwork of these
men. On the scrolls they hold are drawings of just
some of their inventions.

Commissioned from local sculptor William Bloye in
1938, the statue was placed here 'temporarily' in
1956. Originally the bronze figures were covered
with gold leaf to make them even more expensive
and impressive looking, but the gold leaf has worn
away and the yellowish colouring seen today is the
undercoating.

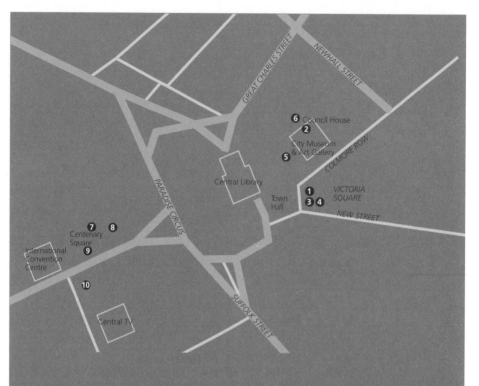

BIRMINGHAM SCULPTURE WALK

1. Queen Victoria
2. Council House
3. Iron:Man
4. River, Youth, Guardians and Object
5. Chamberlain Memorial Fountain
6. Thomas Attwood
7. Industry and Genius
8. Spirit of Enterprise
9. Forward
10. Boulton, Watt and Murdoch

Most of the larger towns across the region have significant collections of public sculpture. Birmingham's city centre has many other works including the Nelson Memorial, 1809, by Richard Westmacott the elder in the Bull Ring and Bruce Williams's Tony Hancock of 1996 in Old Square.

SCULPTURE IN THE REGION

Both sculptures represent a different style from what has become the conventional commemorative portrait statue: Williams has created a contemporary portrait that is original without being disrespectful. In Walsall is a replica of F.J. Williamson's Sister Dora (1886) commemorating a local nursing heroine, said to be the first woman not of royal blood to be commemorated by a conventional portrait statue. The new art gallery here was built in 1999 specially for the Garman Ryan collection of Jacob Epstein sculptures and other works of art, since 1974 housed in the public library.

Other notable collections in the West Midlands include Coventry's sculptures numbering almost 200 works, many still surviving from the sculptural programme that formed part of the city's rebuilding after the Blitz. Coventry's most famous statue is that of Lady Godiva by William Reid Dick, started before and completed after the Second World War. Sculptures of note include Eric Gill's The Good Samaritan, 1957, at the Coventry and Warwickshire Hospital and Jacob Epstein's St Michael and the Devil of 1960 on the exterior of the Cathedral by Sir Basil Spence, built from 1951 over the ruin of St Michael's Cathedral Church. A good example of the work of a local sculptor, Walter Ritchie, is the 1959 pair of panels showing Man's Struggle on the exterior of the Herbert Museum and Art Gallery. The Coventry Canal Art Trail covers many contemporary sculptures.

Other West Midlands counties have sculptures worth seeing: the Ironbridge Open Air Museum of Steel Sculpture in Coalbrookdale at Telford, Shropshire, has around sixty sculptures of iron and steel displayed in natural surroundings; in Stoke-on-Trent's six towns, contemporary work complements traditional statues, some also of the late 20th century. In Lichfield, Staffordshire, are the

statue of the Captain of the Titanic by Kathleen Kennet (Lady Scott), 1914, and Richard Cockle Lucas's 1838 statue of Dr Johnson seated pensively in the market place of his home town (note the fine pedestal reliefs). At Stratford-upon-Avon, Warwick-shire, the large composite Gower Memorial by Ronald Gower and others (1888) is only one of many memorials to the bard, James Butler's Stratford Jester of 1994 being one of the latest.

The impressive Perseus and Andromeda fountain by James Forsyth forms the centrepiece to the historic garden at Witley Court in Worcester-shire, now in the care of English Heritage. The Jerwood Trust is working with English Heritage to develop the Jerwood Sculpture Park at Witley Court, and from late July 2000 aims to display a range of contemporary works by both established and young sculptors.

The prominent symbol of Nottingham Castle acts as the focus of this introduction to the city's variety of sculpture and memorials. There is a notable collection of sculptures in and around the Norman castle's steep sloping grounds. On the northern façade of the Castle is a large stone relief coat of arms of the Duke of Newcastle who rebuilt the ruined Parliamentary stronghold as a mansion in the 1670s, and a much-disfigured equestrian portrait of the Duke (c.1680), carved in the round by Sir William Wilson (1641-1710). This was vandalised at the time of the Reform Act riots. Near here is a plaque marking the spot where Charles I raised the Royalist standard on 22 August 1642, marking the beginning of the Civil War. The Standard had to be re-erected after being blown down in the night.

EAST MIDLANDS

Since 1878, the castle has housed the Castle Museum and Art Gallery - the earliest municipal museum of its kind in the country. An earlier School of Art, established in 1872 by the Town Council, had been housed in the city's Exchange Buildings, Old Market Square. The first exhibition attracted 131,995 visitors, after which the museum's committee members stated, 'the Exhibition is daily teaching, in addition to other great principles, admirable lessons of order and self respect ... mainly due to the refining influence which works of Arts and Sciences have on the multitudes who assemble to study them.'

The statues and memorials in the streets and parks of Nottingham illustrate this notion that art is intended to both decorate and educate. They reveal the history of the city: its role in various conflicts from the Civil War to the Great War and beyond; local heroes; industry and technology; history and legend. Look in the Arboretum, Waverley Street; the historic Lace Market, and along the pedestrianised Albert Street. The Memorial Gardens, on the Victoria Embankment, has a statue of Queen Victoria by Albert Toft (unveiled 1905) which stood in Old Market Square until 1953.

There is a great deal of fine architectural sculpture, including 15 figures at the roof level of the former Elite Cinema, 1921, on the corner of Queen Street and Upper Parliament Street, and an Art Nouveau terracotta female figure on the façade of the Prudential Assurance building that divides

Queen Street and King Street. Literary and historical figures adorn Nottingham Trent University's Arkwright Building in Shakespeare Street (1881). A cement statue of the pugilist-preacher William 'Abednego' Thompson (1811-1880) fronts the Bendigo Arms in Sneinton.

Nottingham University's Campus between Beeston and Lenton is notable for its bust of pharmacist and philanthropist Jesse Boot by C.L.J. Doman (1934), former student at Nottingham School of Art, outside its University Boulevard entrance. Among others, elements from Barbara Hepworth's Family of Man, 1970, are sited near the University library, a statue of D.H. Lawrence by Diana Thomson (1994) is outside the education building and a cast of Hubert Dalwood's untitled abstract bronze and steel sculpture (1974) can be found at the University's medical school.

The grandiose Council House (1929) on Old Market Square, which replaced the Exchange Building, uses sculpture to narrate the cultural, historical and industrial history of this long-established and thriving city. Civic pride has been reflected both by traditional and new sculpture, most recently the commission for Anish Kapoor's Sky Mirror in the forecourt of Nottingham Playhouse, newly landscaped in the year 2000. This short walk through Nottingham aims to illuminate, and increase our appreciation of, an undervalued cultural resource.

NOTTINGHAM SCULPTURE WALK

The walk begins at Nottingham Castle and ends at the Council House, Old Market Square. The route is all downhill with easy disabled access at all sites.

1. Six Memorials to Local Poets

Nottingham Castle colonnade (west façade), from left to right:

Philip James Bailey (1816-1902)
by Albert Toft
bronze bust and bronze panel on granite plinth, 1901

Thomas Miller (1807-1874)
by Ernest George Gillick
bronze bas relief on stone tablet, 1901

William (1879) and Mary Howitt (1799-1888)
by George Frampton, bronze bas relief on granite plinth, 1901

Lord Byron (1788-1824)
by Alfred Drury
bronze bust on granite plinth, 1904

Henry Kirke White (1785-1806)
by Oliver Sheppard
bronze bust and bronze panel on granite plinth, 1902

Robert Millhouse (1788-1839)
by Ernest George Gillick, bronze bas relief on stone tablet, 1904

These six memorials to Nottinghamshire literary figures were erected as directed by the will of William Stephenson Holbrook (1826-1900), Secretary at the castle at the time of its refurbishment (by T.C. Hine) and its opening as a museum. A colonnade was added to the castle's west façade, under which are arranged the sculptures.

The Holbrook Bequest was established for the 'cultural advantage of the city' and for the relief of the poor. Monuments were to be erected to famous local poets, and also to mark spots in Nottingham where interesting historical events had occurred.

Perhaps the most affecting of the Castle sculptures is the scene of William and Mary Howitt, who published many poems, translations and popular histories whilst living in Nottingham, and were eventually awarded Civil List pensions. Kirke White was a Nottingham lawyer remembered for the hymn 'Oft in Danger, Oft in Woe'; Millhouse was a weaver and poet; Lord Byron was buried at Hucknall (where his cement niche statue, 1903, overlooks the market place).

Below Philip James Bailey's bust is a bronze relief illustrating a passage in *Festus*, his own apparently unreadable version of Goethe's *Faust*. Thomas Miller published several novels, poems and children's books, and was awarded a pension by Disraeli; the memorial does not have his image, but instead features two female allegories crouched on each side of a simple inscription.

2. Major Jonathon White (1804-1889)
by Albert Toft
Bronze bust on pink granite plinth, 1891, on sloping path to Museum (opposite the children's play area)

This over-sized portrait is set on a plinth which carries a bronze swag and laurel wreath, upon which is an inscription showing the sincere feelings of the subscribers: 'In affectionate remembrance of the simple manliness of his character and the devotion of his life to the performance of his duty'. Major Jonathon ('Jonty') White was born in Radford, west Nottingham and rose to become Adjutant of the Robin Hood Rifles (formed in 1859). He retired as a Major in 1879, having served in the First Afghan War, which is commemorated by the next memorial on the Walk. The sculptor, Albert Toft, produced a number of war memorials and sculptures of military men.

3. Afghan Campaigns War Memorial
by W. Jackson
Granite obelisk on granite plinth and stepped base beneath the Castle's north front

As the incised gold inscription on the front of the plinth attests, this large obelisk commemorates the officers and men of Her Majesty's 59th Regiment who died in battle or of wounds in the Afghan campaigns from 1878 to 1880. The other three sides of the plinth are covered with the names, ranks and day of death of those who perished, and significantly the main inscription tells us that the memorial was 'Erected by Comrades'. At the time of the Afghan wars it was unusual to find memorials on which the names of common soldiers were mentioned.

4. Captain Albert Ball, VC (1896-1917)
by Henry Poole
Bronze portrait sculpture and allegorical figure on granite and Portland stone plinth with stepped base and bronze sculptures, 1921, south-east part of the castle grounds

Born in Lenton, south-west Nottingham, Albert Ball enlisted with the Sherwood Foresters in 1914, rising to the rank of Second Lieutenant. He transferred to the Royal Flying Corps in 1916, flying with enormous skill and courage: in six months over France he shot down more German aircraft than any other allied pilot. By February 1917 Flight Commander Captain Ball had been made Honorary Freeman of the City of Nottingham, but soon after his return to France on 17 May 1917 his plane crashed as a result, it was reported, of anti-aircraft fire. Such was his standing in the eyes of his adversaries, however, that they claimed his death at the hands of 'a pilot of equal skill'. Ball's exploits were recognised by the

posthumous award of the Victoria Cross: as one of the inscriptions on this memorial states, he was 'England's Airman Hero'.

This fine sculptural group shows Ball in his airman's uniform, but bare-headed as was his custom. Floating up behind Ball is a female allegorical figure of Air, pointing skywards, offering inspiration. The bas reliefs on either side of the plinth show the aeroplane that Ball flew, and a plane over German trenches. Bronze sculptures on either side of the base depict peace fronds and the eternal flame.

The unveiling ceremony on 8 September 1921 was undertaken with great pomp and ceremony, commencing with a procession from the station to the Mayor's parlour, before the unveiling at 3.30 by Air Marshal Sir Hugh Trenchard.

5. Robin Hood
An Idle Moment in the Forest and **Relaxing in the Forest**
by James Woodford
Full-length bronze statue, accompanied by two bronze reliefs, Castle Road (beneath the Castle walls)

Perhaps the best-known statue in Nottingham, Woodford's depiction of Robin Hood shows him firing his bow and arrow in characteristic pose. The two smaller-scale low reliefs set into stone tablets show the Merry Men relaxing in the forest: on one Alan-a-Dale plays the harp to Will Scarlet; on the other Friar Tuck reads to Little John and Will Stukely. They were assembled by Horace Deane of Lambeth. The four relief panels set into the rockface show other scenes from the life (and death) of Robin Hood. His legend is said to date from Richard Coeur de Lion's departure for the Crusades, leaving his brother John in cruel command of Nottingham Castle.

The sculptures commemorate a visit by Princess Elizabeth and the Duke of Edinburgh on 28 June 1949 (the city's quincentenary celebrations), and they were unveiled on 24 July 1952 by the Duchess of Portland. The statue of Robin Hood has always been popular with tourists, as he is the archetypal symbol of Nottingham around the world.

Walk north-eastwards down Friar Lane to Old Market Square, using the underpass to cross Maid Marian Way. Proceed to the western end of the Square, at the junction of Long Row West and Market Street.

6. Quartet
by Richard Perry
Bronze sculpture on low bronze plinth, 1986, on west side of Old Market Square

This life-size group of four figures represents the daily passage of people through the city, based upon observation of human behaviour. Quartet was commissioned by Nottinghamshire County Council in conjunction with East Midlands Arts. The sculpture took seven months to make and cost c. £25,000 before being unveiled by Princess Anne on 5 December 1988. A number of other bronze and painted steel sculptures by different artists were commissioned in the 1980s, and can be found on Maid Marian Way, in the Hockley area and at the Theatre Royal where there is a wire sculpture, Carmen, by Hilary Cartmell (1988).

7. Council House Architectural Sculptures
Architect
T. Cecil Howitt; sculptors Joseph Else and assistants
Portland stone sculptures, high and low reliefs, 1929, east side of Old Market Square

Nottingham's Neo-classical Council House was opened by Edward, Prince of Wales, on 22 May 1929. Its sculptural decoration was the work of the Principal of Nottingham School of Art, Joseph Else (1874-1955), assisted by Charles Doman, Robert

Kiddy, A.W. Pond, Ernest Webb and James Woodford.

The dome, 200ft high, has an allegorical figural group at each corner representing Knowledge, Prosperity, Civil Law and Commerce (only visible by standing well back). The pediment on the west façade carries 21 high-relief sculptured allegorical figures in a modernistic style, representing the Council's activities which include Justice, Architecture, Literature and Education. A low-relief frieze below the pediment extending 25m. across the width of the building depicts ancient trades of Nottingham, as carried out by an army of naked putti. Coal mining, alabaster carving, leather working and textile manufacture are among those represented.

Resting on plinths at ground level are two large Portland stone statues of male lions. This is one of the most popular meeting points for shoppers, and for lovers, and the ending point for this sculpture walk.

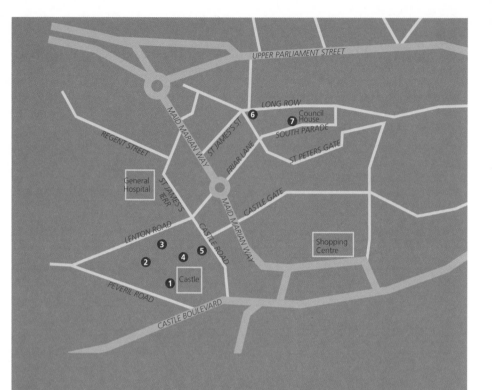

NOTTINGHAM SCULPTURE WALKS

1. Six Memorials to Local Poets

2. Major Jonathon White

3. Afghan Campaigns War Memorial

4. Captain Albert Ball, VC

5. Robin Hood

6. Quartet

7. Council House Sculptures

On the whole East Midlands sculptures are concentrated in the main towns, minor exceptions being Lincolnshire countryside monuments, and not counting contemporary works emerging at the turn of the 20th century. There is a wealth of tomb and memorial statuary within churches, some dating from the 15th century. Uniquely in England, the East Midlands has two of the three remaining Eleanor Crosses raised by Edward I to his consort Queen Eleanor (1245-1290), and sited at resting places along her funeral route from Harby in Nottinghamshire to her burial place at Westminster Abbey. The most complete of these sculptured Gothic monuments is at the village of Geddington, Northamptonshire, while the other is at Hardingstone near Northampton. The examples at Waltham Cross in Hertfordshire (see Eastern England) and Charing Cross, Westminster, have been heavily restored or rebuilt.

SCULPTURE IN THE REGION

Small but rewarding collections of mainly commemorative sculpture can be seen in the county towns, notably Derby, Nottingham, Leicester and Lincoln. Derby has F. Derwent Wood's statue of Sir Henry Frederick Royce, 1923, and a 1914 marble sculpture of Florence Nightingale, by Countess Feodora Gleichen; Nottingham's collection includes work by local sculptors; Leicester, rich in portrait sculptures, has some attractive and individualistic architectural work. Lincoln's prime statue, outside the Cathedral, is the 1905 bronze of Lord Tennyson by the painter and sculptor G.F. Watts, a friend of the poet.

As befits the county towns the First World War monuments are worthy of note, Derby's bronze Mother and Child (William Walker, 1924) being perhaps the most unusual. Northampton's regimental Mobbs Memorial, with bronze bust and accompanying heroic female, is annually wreathed after the town's memorial rugby contest.

Sculptures in the smaller towns have unexpected qualities. Ashbourne in Derbyshire commemorates a woman, Mother of the Salvation Army Catherine Mumford, with a bronze bust; Loughborough has a copy of Spinario (the Boy with the Thorn), a 17th-century French bronze after the antique - the original bronze is in the Capitoline Museum in Rome. Lord Franklin is sited amongst stalls in Spilsby market place; Grantham's bronzes of Tollemache and Newton are well-placed outside the late-Victorian Town Hall. There is a large Gothic memorial to Lord George Bentinck by T.H. Hine (1849) in the centre of Mansfield town - a statue of Bentinck was never installed. Frank Dobson's 1950s concrete Woman with Fish in Delapre Park, unusually for a post-war piece, has grade II listing.

Of country seats, Belton in Lincolnshire (National Trust) has interesting work in the grounds, and a

surpassing collection in the family church, while
at Chatsworth, Derbyshire, is Joseph Paxton's
spectacular Emperor Fountain,1843, part of a
cascade begun in 1694. Late 17th- and early
18th-century sculptures, including Van Nost works,
abound within and around Chatsworth House:
C.G. Cibber's sculpture adorns the pediment. From
modern times, the estate shows not only Elisabeth
Frink's Warhorse but also a bust of the sculptor by
Angela Conner. By contrast, in the Lincolnshire
countryside are one or two oddities, amongst the
best being a bust of the Duke of Wellington on a
column in a field near Woodhall Spa.

More recent work is also represented by Anish
Kapoor's Mirror Sculpture, 2000, at Nottingham.
Rufford Country Park, north-east of Mansfield, has
an Arts Council-funded collection of wood, steel
and stone sculptures dating from the 1980s,
including works by William Pye and Sioban
Coppinger. There is an on-going scheme to site
modern sculptures in the extensive grounds of the
National Watersports Centre at Holme Pierrepont.

Introduction

Admirers of the art may find much of interest in the streets of Norwich, with its odd collection of individual works, mostly 19th- and 20th-century memorials. There are statues in Cathedral Close of the Duke of Wellington, in bronze, by George Adams, and Lord Nelson, in marble, by Thomas Milnes. Norfolk is immensely proud of its native hero, but few would compare this Nelson with his monuments in Great Yarmouth or London.

EAST OF ENGLAND

Norwich Castle Museum, closed for renovation until April 2001, has a small collection including works by John Gibson and John Bell, Norfolk born and bred, as well as post-war works by Henry Moore, Paolozzi and Meadows. Norfolk Contemporary Art Society has for many years commissioned sculpture for public places, particularly Castle Green, which is actually the roof of the recently built Mall car park, an area designated for future sculpture.

Outside Surrey House, Norwich Union's Palladian 1905 mansion-office, are statues of Bishop Talbot and Sir Samuel Bignold by L. Chavalliaud. If entering, be prepared for a spectacular hall, decorated in ten coloured marbles from a cargo intended for Westminster Cathedral. By the door are bronze reliefs of 'Solace' and 'Protection', by S. Young, who also signs the bronze lamps outside. Fronting the Norfolk and Norwich hospital in Newmarket Road is a classical Mother & Child by J. Boehm, court favourite and sculpture tutor to Princess Louise, one of Queen Victoria's daughters.

With fifty-two churches and a Norman Cathedral, Norwich has a mostly hidden wealth of monuments and memorial tablets, not to mention carved bosses and misericords. The Catholic Cathedral is the place to see Gothic Revival gargoyles. Highly recommended is the Victorian cemetery in Rosary Road, where marble angels and bronze obelisks cover a wooded hill.

But it was the Sainsbury Collection, donated by Robert and Lisa Sainsbury to the University in 1973, which put Norwich firmly on the international sculpture map. Housed in the Sainsbury Centre for Visual Arts, it is a large, personal and mixed accumulation of 20th-century sculpture, side by side with ancient Greco-Roman and Mexican carvings and miniatures. Three large works by Henry Moore can be seen in the grounds; his smaller pieces are inside Norman Foster's famous building, with Degas' Little Dancer and impressive works by Giacommetti, Richier, Arp, MacWilliam and Jacob Epstein.

NORWICH SCULPTURE WALK

The walk starts from Tombland, through Erpingham Gate (note the gate's niche sculpture of its builder, Sir Thomas Erpingham) and ends at the Boer War memorial on Agricultural Plain - in walking distance, about 1.5 miles.

1. John T. Pelham, 65th Bishop of Norwich (1812-1894)

by James Nesfield Forsyth
Polished marble reclining figure on ornate red marble base, 1896, in the North Transept of Norwich Cathedral

A polished marble, one of a group of three marble memorials, shows Pelham, Bishop of Norwich, from 1857 to 1893, lying in repose. He died in 1894 aged 82 and his memorial was erected by private subscription in 1896. The choice of the sculptor J. N. Forsyth, who had studied at the RA schools and at the Ecole des Beaux Arts, was the result of his successful memorials to bishops in Manchester and Bristol Cathedrals. Elaborate extras, such as the red marble base and the incised brass lettering, indicate a degree of luxury.

In complete contrast, the neighbouring statue of Bishop Bathurst, a very late work by Sir Francis Chantrey in 1841, shows no polish or definition. Chantrey's talent was for a plain and unencumbered sculptural style, but it might also be observed that Chantrey, in the same year, made at least eight other statues and died a rich man.

2. Afghan Campaign Medal

by E.H.Baily
Marble Relief Tablet depicting Britannia in mourning, South Transept

The first Afghan War, 1839-1842, amounting to almost the total destruction of a large British force in the Khyber Passes, shocked the public. Grief was felt though few monuments were raised, apart from this tablet in memory of officers and men of the East Norfolk regiment, backed by slate and set high on the wall near the door of the south transept.

Flags furled in the background, the superb classical figure of Britannia kneels in deep mourning over a

sepulchre. In high relief, this is nothing less than one would expect from E.H. Baily (1788-1867), who was summoned as a talented boy to assist the immortal John Flaxman even before entering the RA schools. Baily sculpted many highly-rated monuments, including works in Parliament, Buckingham House and the façade of the National Gallery, as well as the 17-ton stone statue of Lord Nelson on his column in Trafalgar Square.

3. Monument to Edith Cavell (1865-1915)
by Henry Pegram
Bronze bust surmounting plinth with rifleman in Portland stone,1918, outside Erpingham Gate, Tombland

Staring bravely ahead, an extravagant bow about her neck, here by the flint wall is the war heroine's memorial in her native city. Inscribed 'Nurse, Patriot and Martyr', the Norwich sculpture was raised by public subscription and unveiled outside the Maid's Head Hotel by Queen Alexandra in 1918.

Edith Cavell was born in Swardeston near Norwich in 1865 and became a nurse; she remained in Brussels after the German occupation of Belgium, tending the wounded of both sides. In 1915, after she had assisted 200 allied soldiers to escape to neutral Holland, she was executed by firing squad. Swardeston village church has a memorial window, and part of the wooden cross that marked her temporary burial place near Brussels. She is buried beyond the east end of the Cathedral.

The virtues of this popular monument are not enhanced by the confusion of messages from the staightforward bust and the plinth below crowded with wreaths and the lone rifleman with bayonet. Cavell's London statue by George Frampton, near Trafalgar Square, bears her words: 'Patriotism is not enough. I must have no hatred or bitterness to anyone'.

4. Samson and Hercules
Two 6 ft white-painted glass-fibre architectural sculptures in replica, Tombland, 1995. (Originals now undergoing conservation - age and origin unknown)

For as long as anyone can remember these thick-legged, long-haired figures have been a meeting place, an extra pair of 'bouncers' to keep the peace, supporting the porch of the 17th-century house (rebuilt after war damage) which has long served as a dance hall or nightclub. Concern for their conservation led to removal of the originals in 1994, after the owners of the building donated them to Norfolk Museums Service, with funding from the city council.

During investigative work at the museum, beneath layer on layer of lead paint it was decided that Samson, with his lamb and jawbone of an ass, is made of oak and may date as early as 1660, while Hercules is a late-Victorian replacement. Was Samson one of a pair of caryatids, possibly of historical importance? The investigation is still in progress.

5. Obelisk and Drinking Fountain
Polished granite, 1860, Tombland (south of the Cavell monument)

Are obelisks sculptural? With 5,000 years' lineage they are certainly monumental, spurring controversy ever since the obelisk became popular again following Nelson's victory at the Battle of the Nile. This rather neglected example, with its disused drinking fountain, replaced an old well and machinery for gathering water for higher parts of the city. It was raised by the Gurney family at the suggestion of the Norfolk-born sculptor John Bell.

While constructing in London a larger obelisk in memory of the Quaker philanthropist Samuel Gurney (1786-1856), Bell had lectured at the

Society of Art about obelisks, drinking fountains and the art-treatment of polished granite. He won a prize for his exposition of Entasis, by which the sides of the obelisk are slightly bulged out to compensate for the illusion of incurvation. By looking at this stubby obelisk with the tapering Cathedral spire in the background, the viewer gains a unique comparison of form.

6. Heraldic Lions
by Alfred Hardiman
Pair of bronze lions, 1936 (1938), standing on either side of steps to City Hall

Seen from afar above the busy stalls of the market place, City Hall is described by Pevsner as 'The foremost English public building [built] between the wars'. A truly magnificent pair of lions with lashing tails, patterned manes and gaping jaws stand like sentinels on either side of steps by the entrance. The architects of the building, C. James and S. Rowland Pierce, visited the British Empire Exhibition of 1936, where they purchased Hardiman's single lion and commissioned the casting of its twin in time for opening of the building by King George VI and Queen Elizabeth in October 1938.

The sculptor, Alfred Hardiman RA (1891-1949), attended the Royal College of Art and studied at the British School in Rome, winning the RBS medal in 1939. He is perhaps best known for his public statue of Earl Haig in Whitehall.

7. Sir Thomas Browne (1605-1682)
by Henry Pegram
Seated bronze figure on stone plinth, 1905, Hay Hill

In this, Pegram's earlier Norwich monument (see Edith Cavell), the tricentenary of Sir Thomas Browne's birth is marked on Hay Hill opposite the house where he practised as a physician, and outside his burial place, St Peter Mancroft Church. London born, he travelled in Ireland and studied in Italy before settling in Norwich; he was knighted during Charles II's visit to the city in 1671.

Author of 'Religio Medici' and the later 'Hydriotaphia', a volume about urn burials, the scholar, antiquarian and naturalist is shown as a meditative figure in period dress, seated upon a curved and heavy chair above a stone plinth. With elbow on knee and hand to brow, Browne contemplates the shard of a broken urn, which he holds in his right hand. The plinth itself is shaped like a squared urn.

Early in his career, Henry Pegram (1862-1937) was assistant to Hamo Thornycroft. He specialised in portrait busts, usually of classical subjects. This popular statue of 1905 shows the sculptor at the height of his power.

8. Untitled
by Bernard Meadows
Abstract composition, 20ft by 10ft. Polished spheres in bronze, with white granite base, 1969, outside Prospect House (Eastern Counties Newspapers)

The untitled, massive, abstract composition which fronts the ECN building is thoroughly at home after 30 years in the city. The sculptor was born in Norwich and went to the Norwich School of Art, at which time he was introduced to Henry Moore and became his assistant for four years. At the time of the commission in 1969, Meadows was Professor of Sculpture at the Royal College of Art, with work in galleries throughout the world.

Meadows took great pleasure in the work for Prospect House. The gilt sign - a tightly packed sack - for the nearby Woolpack Inn in Golden Ball Street, provided the idea of compression. This is expressed in the dimpled shapes, above which the

large gleaming ball, a symbol of optimism, reflects the sky. The entire work is attached to the building which is faced with large blocks and a wall of round flints, a familiar texture in this region, since echoed in parts of the recently-built Castle Mall.

9. Sea Form (Atlantic)
by Barbara Hepworth
Slender bronze rectangle with apertures, 1964, in Castle Gardens

In the gardens beneath the Castle a path leads past Barbara Hepworth's bronze Sea Form, the third in a series of six linked to the landscape of Cornwall. The sculptor, in an earlier letter to Herbert Read, declared 'I was prompted by the sort of associative urge which is sometimes overwhelming on these rocky hilltops to engrave or seek out the secret sign which releases the life of a form at the focal point'.

'Sea Form' was purchased in 1967 by Norfolk Museums Service with grants from the Victoria & Albert Museum and the Gulbenkian Foundation. A punctured megalith in appearance, and yet mask-like in metal, this 6ft abstract dented slab is made transparent by five different holes or gaps opening to the landscape beyond.

10. Victory (Boer War Memorial)
by George Wade and Fairfax Wade
Bronze winged figure above Portland stone plinth with inscribed bronze shields, on an Aberdeen granite base, 1904, Agricultural Plain

A tall, winged female with a sword towers above Agricultural Plain and can be seen from afar down Prince of Wales Road, which leads to the railway station. This is Victory, a beautiful figure, her improbable and stylised wings raised above her head, known to some as Peace, to others as The Angel of Death. She is noted in Pevsner and was restored in 1988. Ionic columns at each corner of the plinth frame bronze shields inscribed with the names of 300 Norfolk soldiers. Set on a large and relatively complex Portland stone plinth with an Aberdeen granite base, which alone cost £1,600, the memorial was erected by General Wynn in 1904. Appropriately, the Shire Hall next to the monument now houses the Norfolk Regimental Museum.

The sculptor George Wade was self-taught, exhibiting at the RA. He specialised in bronze statuettes, either of royal or military subjects, and made public monuments to Edward VII for Bootle, Reading and Whitechapel; his bronze of Queen Alexandra (1908) stands in the London Hospital courtyard.

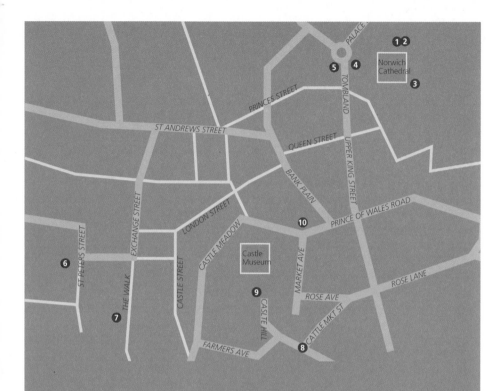

NORWICH SCULPTURE WALK

1. John T. Pelham, 65th Bishop of Norwich

2. Afghan Campaign Medal

3. Monument to Edith Cavell

4. Samson and Hercules

5. Obelisk and Drinking Fountain

6. Heraldic Lions

7. Sir Thomas Browne

8. Untitled

9. Sea Form (Atlantic)

10. Victory (Boer War Memorial)

The eastern counties and their towns and cities, being agricultural and rural, hold a variety of sculpture, widely dispersed, rather than large urban collections of Victorian or Edwardian works. Country houses like Audley End in Essex, Blickling Hall in Norfolk, and Anglesey Abbey near Cambridge are rewarding in their architectural and garden sculpture, whether domestic or monumental, often emblematic of the owners of the estate. Important post-war collections of urban sculpture, domestic-scale, were built in the new towns of Harlow in Essex and Stevenage in Hertfordshire: Harlow's have suffered vandalism. Throughout the region, parish churches contain sculpture of the highest quality of all periods, either integral to the building or belonging to the many monuments in and around churches.

SCULPTURE IN THE REGION

Suffolk and Essex have followed Norfolk's, practice, encouraged by George V, of placing a carved and painted oak sign at the centre of each village or town, decorated with an emblematic scene, whilst the native craft of pargetting, or decorating timbered buildings with plaster reliefs, belongs predominantly to Essex. Rarely seen anywhere in England is the village statue - but in Cambridgeshire the agriculturalist Jonas Webb, by Marochetti, now stands in Babraham and an unsigned bronze bust of the miller Potto Brown scowls on Houghton.

Norfolk has a large monument to Nelson, a 144ft pillar (with interior staircase) at Great Yarmouth, surmounted by Britannia. Another pillar, in memory of the Earl of Leicester, can be seen on the avenue to Holkham Hall. At the base John Henning Jr carved four reliefs illustrating Agriculture. Holkham Hall has 18th- and 19th-century statuary by Nollekens, Banks and Boehm and is open to the public most days in summer and at Easter. The Sainsbury Collection can be visited near Norwich.

Cambridge retains a wealth of 18th- and 19th-century sculpture, chiefly in the colleges and the Fitzwilliam Museum. Trinity College has the largest and finest collection, including Rysbrack's marble statue of Newton (1755) and works by Bacon, Behnes, Cibber, Flaxman, Nollekens, Roubiliac, Scheemakers and Thorwaldsen. The historical balance is made by the 20th-century collection at Kettle's Yard, with sculptures by Brancusi, Gaudier-Brzeska, Hepworth and Moore; and by Michael Ayrton's Talos in Guildhall Street and the war memorial by Eric Gill at Trumpington.

Bedford has bronze statues of John Bunyan by Boehm, and the prison reformer John Howard by Alfred Gilbert. At Woburn Abbey, the Duke of Bedford's Sculpture Gallery shows Rysbrack's limestone Sacrifice to Apollo and several statues

by Nollekens and Westmacott. The Sculpture Park in Luton features contemporary works by Ian Hamilton-Finlay.

Suffolk's old towns hold a few monuments, such as that to Gainsborough at the top of Market Place in his birthplace Sudbury (by Bertram Mackennal - unveiled by Queen Victoria's sculptress daughter Princess Louise), while Bungay has a fine 1754 Buttercross, topped by a graceful Justice without blindfold. The gilded figure of the radical Thomas Paine (1737-1809), by Charles Wheeler, caused consternation in conservative Thetford at its presentation in 1964. Two Tritons were erected on Lowestoft seafront by Morton Peto, builder of nearby Somerleyton Hall with John Thomas, whose sculptures prove that it is possible to be a sculptor and an architect.

In Hertfordshire, the Henry Moore Foundation at Much Hadham shows many of Moore's works in the studios where he worked and in the surrounding grounds. The Maltster, by Jill Tweed, was raised in Ware at the Millennium. Another recent initiative has set up sculptures along disused railway lines near St Albans. Frampton's seated statue of Lord Salisbury fronts Hatfield House, which holds works by Banks and Rysbrack and is open on weekend afternoons (or for guided tours on weekdays).

Colchester's Town Hall is capped by the figure of St Helena, supposed daughter of Old King Cole; its nearby war memorial with sculpture by H.C. Fehr, c. 1920, is particularly fine. The county town of Essex, Chelmsford, has E.H. Baily's 1847 bronze of Sir Nicholas Conyngham Tindal, Lord Chief Justice, sited outside the Shire Hall. John Bacon decorated the pediment of the building with Coade stone reliefs of Justice, Wisdom and Mercy. Inside is a lifesize figure of Hygeia, Goddess of Health, also in Coade stone.

A furore was caused in the town by Sian Cobbinger's 1989 sculpture, involving a pig in a shopping trolly, entitled Bringing Home the Bacon. As in other regions, many new sculptural projects are planned or were completed at the end of the 20th century, amongst them Felixstowe's community-based Forgotten Fleets - projecting old photographs on to the sea wall (which was being renewed), where their stone image remains.

SOUTH WEST

Introduction
Much of the city's public sculpture is discreet - gently inviting rather than accosting. Few grand vistas exist where sculpture dominates. Ancient and modern mingle haphazardly and on this walk you will be diverted by many more than the selected works.

One concerted effort to provide public art occurred ten years ago when Castle Green - site of Bristol's ancient castle - was developed as a sculpture park. At its centre is a tranquil pool with fountains (Peter Randall-Page, Beside Still Waters). Nearby, in a playground of silver sand, children climb on wooden sculptured figures, animals and medieval castles (Andy Frost). Rachael Fenner's Throne invites everyone to interact.

In the city centre courtyard of Broad Quay House a fountain represents the Goddess of the River Severn (The Apotheosis of Sabrina, Gerald Laing, 1981). The new footbridge, sculptured by Eilís O'Connell with the engineers Ove Arup, is a memorial to Pero, an 18th-century slave. A bronze plaque on Narrow Quay gives his story. On College Green stands the marble statue, now sadly vandalised, of Queen Victoria made for her Jubilee by her favourite sculptor, Sir Joseph Edgar Boehm, 1888. By the Council House is a bronze of the great Brahmin reformer, Raja Rammohan Roy, 1998, by Niranja Pradan. William Venn Gough's Cabot Tower on Brandon Hill (1897) celebrates the 400th anniversary of the explorer's departure to Newfoundland and offers wonderful views.

Worthies are celebrated as in every city. Brunel stands on Broad Quay, portrayed by John Doubleday, 1982. At Broadmead, statues by Frederick Brook Hitch, 1938, and Arthur George Walker, 1932, of Charles Wesley and his brother John Wesley on his horse appear either side of the Methodist chapel they founded in Horsefair. At Colston

Avenue the hunched figure of Edward Colston (John Cassidy, 1893) broods over the traffic while William McMillian's Earl Haig, 1931, watches cricket at Clifton College and at Hotwells a marble bust of Samuel Plimsol by an unknown sculptor, erected 1962, watches the vessels on the Avon.

Bristol's harbourside, a working dock until forty years ago, offers little open-air art but, at Baltic Wharf, three works commissioned in 1986 - Atyeo (Stephen Cox), Hand of a River God (Vincent Woropay) and Topsail (Keir Smith) - give hope for the future of statues.

BRISTOL SCULPTURE WALK

The walk begins at William III, Queen Square, and ends at the Cloaked Horseman, Lewins Mead. Overall about 1 mile.

1. William III (1650-1702)

by John Michael Rysbrack [inscription Rysbrach]
Equestrian bronze on a Portland stone plinth, 1736, Queen Square

Bristol was second only to London when, in 1733, the Council gave £500 to enable the city to beat its rival in 'erecting a publick Equestrian Statue of our Great and Glorious Deliverer'. The square had been developed from 1700 with civic pride. Two sculptors, Scheemakers and Rysbrack, both from the Low Countries but working in London, competed for the commission. Their models were 'first Viewed by judges of Art & horses'. Rysbrack won and George Vertue recorded the often repeated accolade - 'the best statue ever made in England'. Peter Scheemakers' gilded version went to Kingston-on-Hull. Transported to Bristol by sea, William III remained on the same spot and survived the Riots of 1831. He left for safety in World War II, and again when the square was restored at the beginning of the year 2000. Monarchs had been represented as Roman emperors long before Rysbrack's version. He possessed engravings showing Marcus Aurelius, the most important Roman statue to survive, and his magnificent work is undoubtably based on these.

2. John Cabot (1483-1557)

by Stephen Joyce
Bronze sculpture, 1894, outside the Arnolfini, Narrow Quay

The departure of the celebrated explorer from the old harbour in Bristol is commemorated by this statue. Five hundred years later over twenty businesses are listed in the Bristol telephone directory with the name 'Cabot'. Joyce, a local sculptor, set his earnest, approachable mariner at pavement level where children climb all over him, polishing his foot bright gold. His rough clothes are a dramatic contrast to the style of Bristol's other

Cabot statue (Sir Charles Wheeler, 1952). That theatrical version is set under the entrance to The Council House on College Green. Visitors and citizens may choose which version suits their image of the man.

3. Unicorns
by David McFall
Gilded bronze, 1950, Roof of Bristol Council House, College Green

There were local and national newspaper 'shock-horror' stories when these sculptures were about to be craned to the roof of the new Council House. The architect, E.Vincent Harris, had quietly ordered them without informing the Councillors before he went on holiday to Italy. The 3.6 metre high gilded mythical beasts - on the city coat of arms since 1569 - were cast from one model and simply turned to face each other. The single 44 cm maquette was exhibited at the Royal Academy in 1951 and is now displayed in the Lord Mayor's parlour. When the press storm subsided the architect explained he had commissioned the unicorns as an alternative to a long piece of ornamental ridging that would have cost £600 more than the unicorns. Harris may have been autocratic but Bristol benefited.

4. Horse and Man
by Stephen Joyce
Two bronze castings at ground level, 1984, Courtyard of Brunel House, St George's Road

Two disconnected life-size bronzes were first very freely modelled in clay. A small man leads an old workhorse towards the arch of the courtyard at Brunel House - now council offices. This was originally the Royal Western Hotel, built by Isambard Kingdom Brunel for travellers to and from America, via Temple Meads and Brunel's steamship the Great Western. When the

transatlantic trade foundered the area became Bristol's main horse market. By the early 1980s the hotel had survived threats of demolition, then, as part of a redevelopment scheme the sculpture was commissioned by the architects Alec French and Partners and unveiled by the Mayor of Bristol in the presence of the sculptor. The secluded setting is, perhaps, known to only a very few Bristolians.

5. Edward VII (1841-1910)
by Henry Poole and Edwin Rickards
Bronze statue and fountain, 1912, Victoria Rooms, Queen's Road

Only months after the King had died in 1910 Bristol City Council decided the space in front of Charles Dyer's excellent 1840 Greek-style building, named to honour his mother, was the best site for a memorial to him. They appointed Edwin Rickards, a London architect, to design a scheme, with fountain and equestrian statue. At the request of George V this was changed and the statue of his father (cast at Frome) stands in robes of the Order of the Garter. Poole had worked previously with Rickards, and in 1912 he also designed extraordinary fountain. Among the exotic sea creatures there are an octopus, a seal eating a fish, and a turtle. At the unveiling a Suffragette dropped a petition into the King's carriage as it made its way along Park Street.

6. Goddess of Wisdom
by Musgrave Lewthwaite Watson
Deep relief in Bath stone, 1839, Victoria Rooms, Queen's Road

Charles Dyer, the architect, is believed to have commissioned this sculpture. This highly-praised group represents Minerva, Roman Goddess of Wisdom, in a chariot guided by Music, Poetry and Light while the Graces follow, scattering flowers. But who did design the work? Most researchers

accept that it was carved, but not designed, by Jabez Tyley, of a family of Bristol masons. The actual creator is thought to have been a sculptor of great promise - Musgrave Lewthwaite Watson, born in Cumberland, who died in 1847 aged only 43. An account of Watson's work on this design is in his biography, published in 1866. His epitaph in Carlisle Cathedral concludes 'art has lost one of her most gifted exponents'. A large bronze relief, The Battle of St Vincent, on Nelson's Column in Trafalgar Square, is Watson's work, while Nelson himself is by Bristol's most renowned sculptor, E.H. Baily.

7. Neptune
by Joseph Rendall [Inscription: John Randall]
Lead, 1723, St Augustine's Parade, City Centre

The origins of Bristol's oldest public statues are not well documented, and there is little information about the sculptor or the making of the statue. It was first erected at a water conduit in Temple Street, and since then has been moved six times. Until the end of 1999 it was closer to the Watershed, and facing the city. Robert Southey, when he saw it in 1807, wrote that the figure was painted in the fashion of similar 18th-century lead sculptures. Recently refurbished, Neptune enters the 21st century as a symbol of Bristol's maritime past and now, more appropriately, faces the river.

8. Edmund Burke (1729-1797)
by James Havard Thomas
Bronze on polished pink granite plinth, 1894, City Centre, Colston Avenue

Strong ties with America and the Liberal ascendancy prompted the decision to erect a statue to Bristol's illustrious MP in 1894. He served the city from 1774 to1780. A similar symbol of friendship with the United States - the Cabot Tower - was begun in 1897. The gesticulating figure of Burke by the Bristol-born sculptor was

cast in Naples and unveiled by the Liberal Prime Minister, Lord Rosebery. Burke's oratory supported American independence and a recasting of this statue is in Washington D.C. - a gift to America in 1922. An often repeated claim says the bronze was merely a copy of a marble statue by William Theed the Younger in the Houses of Parliament. This is incorrect. After the unveiling the Western Daily Press reported on 31 October 1894 that the statue 'must be regarded as the most brilliant in this style Mr. Thomas has yet executed'.

9. St Francis of Assisi
by Judith Bluck
Bronze and resin relief panels, 1974, Greyfriars, Lewins Mead

This large project has six high-relief scenes cloistered on a wall approaching the entrance to the office building. Few Bristol pedestrians or visitors to the city discover this spirited work. Medieval figures, birds and animals present the life of St Francis and his love of animals and birds. The panels are inscribed 'Young Knight', 'Leper', 'Poverty', 'Possessions', 'Clare', and 'Wolf'. A Franciscan community was founded on this site around 1250, less than thirty years after St Francis had died. The story of his life is the subject of controversy but his writings show his love of all natural things. He died in 1226 and was canonised only two years later. The site's history is recorded in a marble slab in the pavement.

10. Cloaked Horseman
by David Backhouse
Equestrian bronze, 1984, Blackfriars, Narrow Lewins Mead

St Bartholomew's Hospital, a Blackfriars foundation, cared for the sick and travellers from the early 13th century. Bristol Grammar School occupied the site from 1523 to 1767, then Queen

Elizabeth School stood there until the mid-19th
century. An archaeological investigation in 1978
revealed a medieval bridge crossing the River
Frome that runs beneath the road: this inspired
the sculptor to create his apprehensive traveller,
arriving outside the city and gazing towards
St John's Gate through which he will enter.
Backhouse made the life-size plaster version in
his Bradford on Avon studio, and this was cast in
bronze at Burleighfield Studios in High Wycombe.
The statue is a gift to the City from the office
developer.

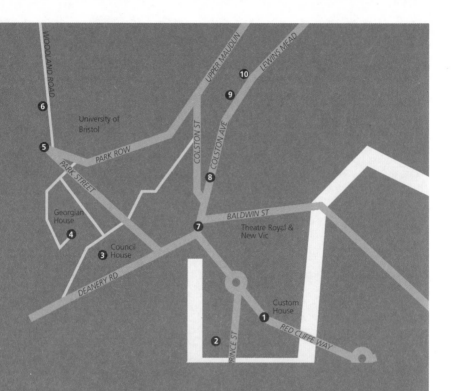

BRISTOL SCULPTURE WALK

1. William III
2. John Cabot
3. Unicorns
4. Horse and Man
5. Edward VII
6. Goddess of Wisdom
7. Neptune
8. Edmund Burke
9. St Francis of Assisi
10. Cloaked Horseman

The major towns, and certainly the eight cities in this large region, possess sculpture of their local heroes and heroines. Apart from some war memorials and contemporary commissions, these are usually the most notable sculptures. As in other regions, country houses such as Stourhead in Wiltshire (National Trust) have classical temples and sculptures.

SCULPTURE IN THE REGION

In Cornwall Sir Humphry Davy (W. & T. Wills), the exceptional scientist of the early 19th century, commands his birthplace - Penzance. At Cambourne, L.E. Merrifield's 1932 bronze of the inventor Richard Trevithick holds a model locomotive.

Plymouth and Exeter are rich in public art, old and new. Sir Joseph Boehm's bronze of Francis Drake strides the Hoe next to the Armada Monument by E.W. Charles May, 1890. Another cast of Boehm's Drake was erected a year earlier in 1884 at Tavistock, near Drake's birthplace. Exeter University is a veritable sculpture park: work by Henry Moore (Reclining Connected Forms, installed 1996), Barbara Hepworth (Figure for a Landscape, 1965) and a host of other 20th-century artists adorn the campus. Exeter's City War Memorial of 1932, by John Angel, is spectacularly ambitious.

An unusual wayside piece in Somerset, on the A39 north of Wells, is a copy of Romulus and Remus (Lupa Capitolina) made in cement by an Italian prisoner of war, Gaetano Celestra, c.1943. Bridgwater celebrates one of the region's many sea-going heroes, Admiral Robert Blake, in F.W. Pomeroy's bronze of 1900.

Thomas Hardy, seated in old age, is portrayed in Dorchester by Eric Kennington, 1931. Not far away at St Peter's Church is the statue of the poet William Barnes (Edward Roscoe Mullins,1888), his epitaph in Dorset dialect. Just outside the town on the site of the former gallows is Elisabeth Frink's 1986 bronze group recalling Anglican, Catholic and Non-conformist martyrs of the16th and 17th centuries.

Wiltshire's county town Salisbury, outside the Cathedral, has Frink's striding figure of the Madonna. Henry Fawcett (1833-1884), Postmaster

General, is honoured by Herbert Pinker's bronze in the market place: Baron Marochetti's 1887 bronze of Lord Herbert of Lea has been moved to Victoria Park: Diana Dors stars outside the MGM cinema in her home town of Swindon. This work by John Clinch, 1991, was part of the Borough's contemporary public sculpture commissions made in the late 1980s and early 1990s. Clinch also made The Great Blondinis in aluminium alloy, in sugary pastels, for Swindon's Brunel Centre in 1987.

An untypical piece - in Cheltenham - is a modest drinking fountain where Ambrose Neale shows Edward VII, 1914, wearing not robes but a Norfolk jacket. Dr Edward Wilson (Lady Scott, 1914), the Antarctic's explorer's companion, stands dutifully on the Promenade, which also has Neale's bronze Boer War soldier and, at the top, a version of Salvi's Trevi fountain in Rome. The town's racecourse has immortalised four winning horses in bronze in recent years.

Contemporary projects are evident in Gloucestershire and all parts of the South West. Cheltenham's include Sophie Ryder's Minotaur and Hare (bronze, installed 1998), and a sculptural cycle rack by artist-blacksmith Alan Evans (1933), both in the town centre. Cycle ways and way-marked walks lead through the Forest of Dean - the Sculpture Trail includes work by Bruce Allan, Kevin Atherton and Cornelia Parker. The Poets' Walk at Clevedon in Somerset has leaning posts by Michael Fairfax; the Bristol to Bath Railway Path, part of the SusTrans project to make national cycleways, includes a waymarker Fairfax fountain. At the disused workings of Tout Quarry on Portland in Dorset, the Portland Sculpture Trust's sculpture walks reveal work by Antony Gormley (Still Falling), Dhruva Mistry (Woman on Rock) and others carved straight into, or placed around, the very rock. Further west on Dartmoor, the landscape

art group Common Ground has commissioned works by Peter Randall-Page.

Notable galleries include the New Art Centre Sculpture Park and Gallery at Roche Court, East Winterslow near Salisbury, which puts on sculpture events and temporary exhibitions and shows new works in a pastoral landscape. Tate St Ives, with its spectacular glass window (Patrick Heron, 1993) runs a continuing project of public art commissions in the town. The Bath Festival features annual contemporary art exhibitions. Ray Smith's lighting artwork, Making Waves, shines after dark at Teignmouth. In Bristol, Diane Gorvin and Philip Bewes have created a 10m high bronze Circadian Sculpture above Parkway.

Introduction

A walk through Winchester brings sculpture into view at every turn. The heroic statue of Alfred the Great is a fitting beginning in a city which, during his reign, was the centre of European culture whose monks were noted for illuminated work and carving in bone, and whose nuns for fine needlecraft. Carvings on the nearby Victorian Gothic Guildhall reflect city history, as do trade signs over the shops, or figurative and emblematic sculptures on High Street buildings like Boots the Chemist embellished with figures of medieval bishops. Queen Anne's painted lead image on the former Town Hall carries a historical slogan.

SOUTH EAST

Further along past Elisabeth Frink's Horse and Rider, near the Westgate and the Hampshire Hogs by Gill and Kemp, stands the Plague Monument, an obelisk erected in 1759. It pays to read the inscription. The Great Hall has the Round Table, but also Alfred Gilbert's brilliant bronze statue of Queen Victoria, and the 1981 Royal Wedding Gates by Anthony Robinson. The fountain in Queen Eleanor's Garden carries a bronze falcon.

Turn towards the Cathedral at the 15th-century Gothic Buttercross (much restored by George Gilbert Scott in 1865, with a statue thought to represent St Lawrence). Outside the west front is the Rifleman by John Tweed (1922), a student of Hamo Thornycroft's, and on the gable of Herbert Baker's War Memorial Cloister is a Madonna by Charles Wheeler, an early piece of direct carving.

To enter the Cathedral, and concentrate on the north transept and crypt with three sculptures by Eric Gill, Peter Eugene Ball and Antony Gormley, is to whet the appetite for the rest. The Cathedral over the years has been a great patron of the arts, showing sculptures of Joan of Arc by Comper, Bishop North by Chantrey, the Merchant Navy memorial by Skelton and many more. A delightful oddity is Charles Wheeler's 1960s commemorative bronze of William Walker wearing the diving gear in which he saved the Cathedral from collapse, 1906-1912, by laying bags of concrete under the flooded foundations. On Mirabel Close is Hepworth's Construction, whilst the Egyptian State God

Serapis, representing Water, lurks in the
Magnolia grandiflora in the Water Gardens
east of the Cathedral.

Elsewhere a superbly beautiful and calm
Madonna and Child (early 15th century),
originally polychrome, adorns the gateway
to Winchester College, College Street, and
in a niche over the private entrance to the
School is C.G. Cibber's 1692 carving of its
founder, William of Wykeham. On the lawn
behind the new Hampshire Records Office,
near the main railway station, is The Family
in bronze by Glynn Williams.

WINCHESTER SCULPTURE WALK

The walk starts at Broadway and ends in the Sculpture Court. About 1 mile.

1. Alfred the Great

by Hamo Thornycroft
Bronze statue on Cornish granite plinth, 1901, The Broadway

This monumental figure was commissioned by the Mayor of Winchester at about the time of the millennium of Alfred's death. There was national enthusiasm to celebrate the 'Hero King of Wessex'. He is shown as a Christian soldier holding his sword as an emblem of the Cross. Two-and-a-half times life size, weighing five tonnes with a total height of 40ft, the statue took eleven months to cast, with a certain amount of drama when one of the sheerlegs collapsed as the figure was being hoisted into place. Only the nose suffered damage.

Hamo Thornycroft (1850-1924) was the son and grandson of sculptors. Like his contemporary Alfred Gilbert, he was a leader of the New Sculpture movement in England, moving away from the Neo-classical ideal. In his teaching he stressed 'La jambe qui porte', meaning that action just taken, or about to be taken, is best conveyed by accurate depiction of the load-bearing leg.

2. Queen Anne (1665-1714)

'Anno Regina Anno Pacifico 1713', artist unknown
Lead figure, Lloyds /TSB building, High Street

This niche statue was given to the city by George Brydges, one of the Liberal Members of Parliament for Winchester, the other being the Marquis of Winchester who gave the clock. It was hoped the Queen would complete and live in the King's House (architect Christopher Wren), built on the Castle site for Charles II but unfinished at his death in 1685. However, she died before this could come about.

As implied in the inscription, the statue was also a celebration of the Treaty of Utrecht and peace with Louis XIV, as were many other statues of Queen

Anne erected in towns and cities throughout England. The original building on this site was the third Guildhall of the city (rebuilt 1710). Further along the High Street, at the traffic lights high up is a wooden life-size carving (by Lavety, 1932) of a black swan with crown-like collar and bunch of grapes, on the site of the hotel of that name mentioned in *Copper Beeches* by Conan Doyle.

3. The Horse and Rider
by Elisabeth Frink
Bronze sculpture, 1980, High Street (near the West Gate)

In 1980, the property company Trafalgar House and the Arts Council funded a Frink exhibition in the Great Hall and its environs. In this period a large holm oak on this site had to be felled and it was decided the version of the Horse and Rider at the exhibition would fill the space well. Frink was a great advocate of public outdoor sculpture, so this would have pleased her.

The daughter of a cavalry officer, Frink was familiar with horses and was able to show man and horse in complete harmony and balance. As an art student influenced by Henry Moore and Giacometti, she used direct plaster and carved into it as they did, before casting into bronze.
This is a good site for Frink's Horse and Rider - especially so for the partially sighted - it being silhouetted against the white wall of the shop to the left. The first edition of the sculpture (1974) can be seen outside Trafalgar House in Dover Street, London, where it meets Piccadilly.

4. The Hampshire Hog
by David Kemp
Bronze figure, 1989, near the West Gate

Arguments on whether the Hampshire Hog, the symbol of Hampshire, was actually a pig or a sheep raged for some weeks in the local papers when it was announced a statue of a Hampshire Hog would be commissioned to celebrate the County Council's centenary in 1989. The hog's origins are documented, the argument is never quite resolved. The figure stands on the ground amongst a complex of County Council offices, life-size, accessible to all and acquiring a patina where people touch him. His sculptor David Kemp was born in Hampshire, but now lives in Cornwall.

To complete the Hampshire Hog story: in the Queen Elizabeth II Court nearby - the right hand entrance (open office hours only) - is a hog in Portland stone carved by Eric Gill and purchased by the County Council when it came on the market in 1998. It dates from the time Gill set up his workshop in Hampshire Hog Lane in London in 1913 in what had been a butcher's shop. He used the Hog as his logo on letterheads. Look upwards - there is a Hog on the windvane.

5. Queen Victoria (1819-1901)
by Alfred Gilbert
Bronze statue, 1887, in the Great Hall (entry free)

Alfred Gilbert (1854-1934) is perhaps best known for the Shaftesbury Memorial - Eros - in Piccadilly Circus in London, unveiled in 1899: its celebrity has almost overshadowed his other works. The enthroned figure of Victoria, merited as amongst Gilbert's best work, was commissioned for her Golden Jubilee celebrations of 1887 by the High Sheriff of Hampshire. Originally intended for outside the Great Hall, it was moved in 1894 to Abbey Gardens, then into the Great Hall for safety.

The sculpture is embellished and encrusted with allegorical figures representing the Arts and Sciences, and with the panoply of Empire and Commonwealth. It was cast in Belgium, as no English firm could complete the project on time. Gilbert later retired to Belgium (after a period as Professor at the Royal College of Art) as a result of

suffering the humiliation of bankruptcy in 1901. Another cast of this acclaimed statue of Victoria can be seen with a differently-designed canopy outside the Cathedral at Newcastle (see p.86).

It is interesting to note that Winchester has major works by Gilbert and Thornycroft - rivals for the Academy Gold Medal in 1875, both knighted, and both leaders of New Sculpture in England.

6. Royal Wedding Commemorative Gates
by Anthony Robinson
Stainless Steel, installed in the Great Hall in 1983

These beautiful gates at the east end of the Great Hall lead to the stairs going up to the Judges' Gallery of the Law Courts. They had to be narrow enough for security but to reflect the nature of the Hall, so there is the glint of chain mail armour and medieval weapons as handles in the Gothic arches. The scrolls elongate to form tridents which widen and flatten to form the wings of a butterfly, with the initials C and D and the date, 1981.

Anthony Robinson is a sculptor and blacksmith living in Shrewsbury. This important commission attracted help from smiths in Germany and Switzerland, as well as this country. The materials were the gift of British Steel.

7. The Lamb of God
by Eric Gill
Stone carving in the Epiphany Chapel, North Transept of Cathedral

This was installed in 1993, perfectly complementing the quiet contemplative nature of the chapel, which is set aside for private worship. The son of a parson, Gill trained as an architect but by 1910 was a figurative sculptor influenced by his socialist ideals and his conversion to Roman Catholicism. He completed the fourteen Stations of the Cross for Westminster Cathedral 1914-18. He worked

also as a wood engraver and a letter-cutter, designing a number of distinguished typefaces, notably Perpetua. His typeface Gill Sans has been used for this book. He was one of the pioneers of the 20th-century direct carving revival.

Gill set up a community in Ditchling, Sussex - anti-industry and capitalism - his thinking being that all had gone wrong at the Industrial Revolution. His nephew, John Skelton (d. 1999), has pieces of work in Winchester Cathedral, including the Memorial to the Merchant Navy at the west end.

8. Christus (Crucifix)
by Peter Eugene Ball
Wood, copper, gold leaf, high up on north wall of the North Transept

This image of the risen Christ, arms outstretched in crucifixion or embrace, was first seen at an exhibition of Ball's work in 1990 when it so moved a member of the congregation that she made a gift of it to the Cathedral. Look at the energy in the spirals and whirls like comets in gold leaf. Ball searches for driftwood and uses other discarded materials, particularly from the sea and shaped by the elements.

Born in Coventry, Ball attended Coventry College of Art and had his first one-man show in Chelsea in 1961. Other works of his in the Cathedral are the Pieta in the Lady Chapel, a truly moving image, and the Nativity figures in place around Christmas time near the Holy Hole. Also, in the Silkstede Chapel (south transept), he has made an altar table from a massive piece of oak with two of the apostles depicted as candlestands. These echo the theme of the chapel, which is where Isaak Walton, author of The Compleat Angler is buried. It is known as the Fishermen's Chapel. The seating reflecting the theme of water is by Alison Crowther.

9. Sound II
by Antony Gormley
Lead figure, installed in 1986, Cathedral Crypt

This remarkable work, given by the artist in 1986, as in so much of his work is in lead, to throw off different colours, and made from a cast of his own body. Hands held near the heart symbolise the flow of energy from earth to heaven.

Gormley intended the figure to stand in or near water, symbolising contemplation and a sounding of the depths of one's soul. Water floods into the Crypt naturally in the winter and then one can see the reflections of the figure and the Norman arches which emphasise, as documented on a notice in the Crypt, the various definitions of Sound: 'what may be heard - noise and quiet / a strait of flowing water / feel, experience, measure and depth / health, life giving'.

Antony Gormley is one of the outstanding sculptors of his generation in Britain, and came to general prominence when his large-scale Angel of the North was installed at Gateshead, near Newcastle. His Millennium Man was one of the celebratory sculptures put up in Greenwich for the year 2000.

10. Construction (Crucifixion)
by Barbara Hepworth
A Homage to Mondrian, Bronze 3/3, installed in 1997 in the South-East Sculpture Court, Cathedral Close

After some years in the Cathedral Close at Salisbury, then on display outside the Cathedral at Portsmouth, this piece finally arrived in 1997 at Mirabel Close (in the inner Close) with much disruption to traffic - it had to be hoisted over the top of Prior's Gate. It is one of an edition of three. It represents the Crucifixion with the three crosses in rudimentary forms and primary colours, to be

seen from either side, and making spaces where one can enter; it is meant to be at home on a hillside or in a cathedral, and relevant in 2000 years time.

There is always a sense of God in Hepworth's work, particularly in her increasingly abstract works. To her religious pieces she rarely gave a title, usually preferring to number them. She was the first abstract sculptor in England: although she participated in International Constructivism, she brought to it a unique quality of her own.

WINCHESTER SCULPTURE WALK

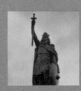

1. Alfred the Great

2. Queen Anne

3. The Horse and Rider

4. The Hampshire Hog

5. Queen Victoria

6. Royal Wedding Commemorative Gates

7. The Lamb of God

8. Christus

9. Sound II

10. Construction (Crucifixion)

This is a large and varied region, with statues of local worthies in market squares and county towns, and a larger sculptural presence in the ports of Southampton and Portsmouth. Two of the three Manning Ports of the First World War, Portsmouth and Chatham (Plymouth being the third) have big architectural memorials in Portland stone, by Robert Lorimer and Edward Maufe, with stone sculptures of naval personnel. At Egham in Surrey is the RAF pavilion by Maufe (1953), a unique integration of architecture and art. Much earlier, Oxford colleges integrated stone statues of founders and benefactors onto the old gateways, like college founders Nicholas and Dorothy Wadham in Wadham's Front Quad. George Gilbert Scott's Martyrs' Memorial, a scholarly rendition of the Eleanor Cross with Caen stone sculpture by Henry Weekes, contributed to the Church of St Mary Magdalen's restoration in 1841.

SCULPTURE IN THE REGION

Country estates like Blenheim, Oxfordshire, or the grounds of Stowe in Buckinghamshire, are rich in sculptures reflecting their history, notably Robert Pitt's lead figure of the Duke of Marlborough (with winged Victory) at Blenheim, raised on a column with Bolingbroke's heartfelt inscription on the base. Stowe's grounds, renowned for their temples and sculptures, have stone busts by Rysbrack and Scheemakers, and a lead equestrian figure of George I (1720) attributed to John Nost. A particularly striking equestrian sculpture, by Richard Westmacott the Elder (1832), is that of George III - its monumental silhouette clearly visible at the far end of Windsor Castle's long, Long Walk.

As in other regions, country town statues tell local and social history. The Parliamentarian John Hampden (bronze, H.C. Fehr, 1912), stands in Aylesbury, Buckinghamshire; Reading's statues include the Biscuit King George Palmer, sculptured in bronze by George Simonds of the brewing family; General Wolfe (F. Derwent Wood, 1911) stands in his birthplace Westerham, Kent, with Churchill in bronze by Oscar Nemon, 1969, also on the Green; Romsey in Hampshire has Matthew Noble's 1867 figure of local landowner Viscount Palmerston in the market square. A Petersfield benefactor gave the town its 18th-century lead equestrian sculpture of William III, sculptor unknown. On the Promenade at Folkestone, Kent, stands a son of the town, renowned physician William Harvey (1578-1657), holding a human heart (Albert Bruce Joy, 1878).

Statues occupy sea fronts all along the coast: Dover has Lady Scott's 1912 bronze of the engineer and aviator C.S. Rolls in flying kit (Bleriot's monument, a concrete relief of his rudimentary aircraft, is set into the Castle grounds); Eastbourne, West Sussex, shows its founder the 7th Duke of Devonshire (W. Goscombe John, 1901) seated on

the Promenade - the 8th Duke by Alfred Drury stands nearby. Brighton, in the Pavilion Gardens, has Francis Chantrey's 1828 bronze cast of its patron, George IV. One of the South-East's many fine war memorials, the Sussex Regiment Boer War Bugler, 1904, by Charles Hartwell occupies Regency Square. Four outsize Frink heads, Desert Quartet I-IV, 1989, overlook Regency Worthing from the rear of the Montague Shopping Court.

Exceptions and oddities occur across the region. Gravesend, Kent, has a bronze copy of Pocahontas, 1907, by William Ordway Partridge of New York; at the Royal Engineers' Brompton Barracks, Chatham, is Onslow Ford's 1890 cast of General Gordon on camelback. Matthew Cotes Wyatt's massive, rejected equestrian bronze statue of the Duke of Wellington (1846) stands in a wood near Aldershot. In minor vein is the stone-carved bat, ball and stumps, 1908, outside the Bat and Ball pub at Hambledon, Hampshire - home of cricket until relocation to Lords' Cricket Ground.

One of the region's great sculptures is Alfred Gilbert's bronze seated figure of Queen Victoria, in the Great Hall at Winchester; busts of Charles I occupy niches in Chichester's Market Cross and at Portsmouth's Square Tower. Both are now glass fibre, the Portsmouth original safe in the city museum. Chichester's, reputedly by Hubert le Sueur, can be seen by arrangement at the Council House. Southampton's Bargate has a statue of George III; particularly fine amongst the city statues and sculptures is its bronze and stone memorial to the Titanic Engineers. Across the road is the city's First World War Cenotaph, carrying a recumbent soldier, by Edwin Lutyens. City art galleries in both ports are building collections of contemporary sculpture.

Contemporary sculptures show well in Sculpture at Goodwood, the East Sussex sculpture park where work by leading British artists is marketed and displayed. Horsham has a spectacular kinetic globe fountain by Angela Conner, 1996, commemorating the poet Shelley - born there in 1792. Projects large and small are in progress throughout the region. At Milton Keynes, whose progressive sculpture programme in the 1960s-80s kept pace with the developing new town, much remains, although now in the hands of individual owners: commissions are planned for the landcaped sculpture park. The new Theatre and Gallery has a series of five sculptures leading there from the station along Midsummer Boulevard, amongst them Michael Sandle's bronze, A Blow for Freedom, in Market Square.

Introduction

You cannot go far in the City without meeting its lavish armorial displays. At the end of the 19th century, when the City's character and functions were undergoing major change, the Corporation redoubled its efforts to disseminate these symbols of civic identity. The spiky outlines of the City Dragons (often erroneously described as griffins) are found on bridges, market halls, and on such commemorative structures as Temple Bar Memorial in Fleet Street. More recently these fabulous monsters have shown up again, of all places in Bank Underground, in reliefs by Gerald Laing.

LONDON

Amongst commemorative statues, royalty once prevailed numerically, in recognition of the rights and privileges conferred on the City by monarchs. Now all the free-standing Kings have gone, leaving only Queens (Elizabeth I, from the old Ludgate, on St Dunstan-in-the-West, Anne in front of St Paul's, and Victoria at Blackfriars Bridge) and Princes (Albert and Edward of Wales on Temple Bar Memorial, Albert on horseback at Holborn Circus).

In the Victorian period, the City was the scene for pioneering representations of work in sculpture, culminating in W.H. Thornycroft's building frieze on the Institute of Chartered Accountants, Great Swan Alley. Usually these depictions reflected industrial activities, which were dependent on the financial services of the banks (relief panels on the National Westminster Bank, Bishopsgate) or used a metropolitan Livery Hall for ceremonial purposes (terracotta frieze on Cutlers' Hall, Warwick Lane). Between the Wars, the City's own financial activities were symbolised on the rebuilt Bank of England in sculptures by Charles Wheeler.

In our own days, sculpture has been used
to humanise the City's open spaces. The
Corporation led the way in the early 1970s,
encouraging donation of pieces like Michael
Ayrton's Minotaur (London Wall Gardens), or
Georg Ehrlich's Young Lovers (Festival
Gardens, SW of St Paul's). In the capitalist
ebullience of the eighties, property
developers took up the standard. Rosehaugh
Stanhope (now Broadgate Properties) have
treated the piazzas at Broadgate and Fleet
Place as if they were open-air galleries of
modern art.

LONDON SCULPTURE WALK

The walk starts at Monument Yard near Fish Hill Street, and ends at Exchange Square, Broadgate. Overall, about 1.5 miles.

1. The Monument

by Christopher Wren and Robert Hooke, sculptors
C.G. Cibber and Edward Pierce
Stone column, gilt bronze urn, 1671-77,
Monument Yard

At 202 feet this is the tallest of London's commemorative columns. It was inspired by the columns of ancient Rome and Constantinople, and was erected by Act of Parliament as a reminder of the Great Fire which ravaged the City in 1666. It is a Doric column, supported on a plinth with long Latin inscriptions describing the Fire and the measures taken for rebuilding. On the west side of the plinth is a fine baroque relief by Cibber, showing King Charles II coming to the support of the afflicted City. Easy to miss, because of their elevated position, are the four vigorously carved and very large City Dragons, at the corners of the column base. The Monument has an interior staircase, and on certain days is open for ascent.

2. James Greathead (1844-1896)

by James Butler
Bronze statue, 1993, Cornhill

Before the erection of this rather recent monument to a great Victorian, Greathead was one of the unsung heroes of 19th-century engineering. He invented the Greathead Shield to facilitate tunnelling in inner city areas. The London Underground could not have been built without it. The circular relief at the base of the high plinth shows tunnelling in progress, and has inspired the sculptor to create a perspective illusion in the style introduced by Donatello in the 15th century. The statue itself is quietly naturalistic and contemplative, Greathead's face permanently shadowed by the brim of his hat. The distinctive ovoid plinth doubles as an air-vent for Bank tube-station beneath, an apposite reminder of the subject's accomplishments.

3. The City of London Overcoming Faction
by Robert Taylor
Stone pediment sculpture, 1746, Mansion House

Mansion House was designed in Palladian style as a residence for the Lord Mayor, by George Dance the Elder, and built between 1739 and 1752. It is an expression of the growing political and financial power of the City. Taylor won the commission to execute the pediment in competition with some of the most eminent sculptors of the period, including the great Roubiliac. He had City connections and was inevitably suspected of graft, but he was an original and elegant sculptor, as successful in this as he was later to be in architecture. The protagonists in this dramatic allegory are the City, with a crown of turrets on her head, Faction writhing beneath her, with snakes twisting round his head, a River God representing Thames, and a beautiful woman representing Abundance.

4. Arthur Wellesley, 1st Duke of Wellington (1769-1852)
by Francis Chantrey
Bronze equestrian statue, 1838-44, Royal Exchange

The Duke's admirers could not wait to commemorate him. In the immediate aftermath of the Napoleonic Wars, the colossal statue of Achilles was erected in his honour in Hyde Park. The diehard conservatism of the hero of Waterloo had infuriated supporters of parliamentary reform, but by the end of the 1830s the Duke's health was failing, and portrait statues began to be proposed. The City's statue was a thank-offering for the influence the Duke had used to get a bill passed through Parliament for the rebuilding of London Bridge. The sculptor, Francis Chantrey, died in 1841, long before the inauguration of the statue. It had to be completed by his assistant Henry Weekes. It is an imposing example of Chantrey's no-nonsense classical naturalism. The Duke does not swagger, and his horse has all four feet on the ground.

5. 1914-18 War Memorial to London Troops
designed by Aston Webb. Sculptor: Alfred Drury
Bronze, Portland stone and granite, 1919-20, Royal Exchange

The memorial is a restrained baroque plinth with convex inscription panels at front and back. It is surmounted by a bronze lion, presenting a medallion with St George and the Dragon. On either side in bronze, standing on rounded plinths, are two soldiers of the London Regiments, one middle-aged, the other more youthful. Behind them, on the stone plinth are regimental flags in low relief. The memorial was designed in relation to the nearby Wellington monument. Here there is no single hero crowning the plinth. The general has stepped down in deference to ordinary soldiers, who might in earlier times have been mere accessories to his monument.

6. The Earth is the Lord's and the Fullness Thereof
by Richard Westmacott the Younger
Stone pediment, 1842-44, Royal Exchange

The old Royal Exchange burned down in 1838 and was rebuilt by Sir William Tite from 1841. Tite changed the building's axis so that it dominated the streets converging at Mansion House. The Richard Westmacott who sculpted this pediment was the son of the more celebrated Sir Richard Westmacott, author of the pediment of the British Museum. The younger Westmacott's relief is quite unlike his father's work, and is in still more striking contrast to the one on Mansion House. Personifications, stock-in-trade for such architectural features, have been reduced to one. An allegory of Commerce stands at the centre,

presiding over an international assembly of merchants, shown conducting their business in stone. London was still at this point a significant port.

7. Ariel
by Charles Wheeler
Gilt bronze sculpture, 1934-36, Bank of England, Princes Street/Lothbury

The architect, Sir Herbert Baker, caused a great uproar by remodelling the so-called Tivoli Corner of the Bank, designed originally by the Neo-classical architect Sir John Soane. The public was compensated with a remarkable cupola, open to the sky, and this bronze statue on the dome above. The programme of sculpture on the renovated Bank was elaborate in its symbolism. Ariel was first referred to as The Spirit of the Winds, and was intended to represent the dynamic spirit of the Bank, carrying the 'magic invisible spirit' of Trust 'over the wide world'. This glistening figure, with its floating draperies reflects the influence of the Swedish sculptor Carl Milles, very much the flavour of the moment in the 1930s.

8. Architectural Sculptures
by John Hancock and Charles Mabey
Stone relief panels, 1864-65 & 1878-79, National Westminster Bank (originally National Provincial Bank), 15 Bishopsgate

These premises, designed by John Gibson, epitomise the thrusting spirit of the Joint Stock banks which, in the second half of the19th century, threatened the monopoly of the City's old-established family-run banks. It is a Renaissance-style palace, with a rich texture of sculpted ornament. The bank, as first built, had only six bays. The two bays on the right were added later. The first six reliefs, by the Pre-Raphaelite sculptor John Hancock, illustrate Art, Science, Commerce etc. with quaint medleys of figures, presided over by allegorical female geniuses. The two panels added by Charles Mabey illustrate industrial activities with a new frankness and in a more vigorous style of relief.

9. Fulcrum
by Richard Serra
Cor-Ten steel - five plates - 55 ft high, 1987, Broadgate, off Eldon Street

The San Francisco-born Serra worked in his student days in steel mills, which may explain his predilection for this material, although he has also worked with lead, neon, rubber and other materials. His steel is served raw, without any welding, polishing or other trace of the artist's touch. Serra slices space with his metal sheets, and this has sometimes made him enemies. At the time when Fulcrum was commissioned, controversy was raging in New York around Serra's curved metal screen, Tilted Arc, which certain petitioners wished to see removed from Federal Plaza. Absurdly, Arc was removed by the authority which had commissioned it. Fulcrum was a site-specific commission from the developers of Broadgate, and was created after consultation with the architects, Arup Associates.

10. Broadgate Venus
by Fernando Botero
Bronze female nude, 1990, Broadgate, Exchange Square

Like Serra's Fulcrum, this sculpture was commissioned specifically for Broadgate. Botero is a Colombian, who practises both painting and sculpture. In its evident relish of corpulence, the Venus is typical of Botero's work but, where many of his figures tend to the impassive and static, this one is full of movement, looking as if she has just fallen to earth - an effect to which her situation at

the foot of a high office tower contributes.
Botero's voluminous forms are never inert, his
details and extremities strangely dainty. Asked in
an interview whether he found fat women
attractive, Botero replied that the beauties of art
and reality were two quite different things.

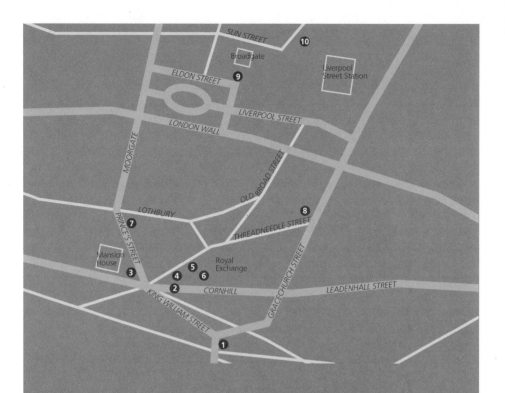

LONDON SCULPTURE WALK

1. The Monument
2. James Greathead
3. The City of London Overcoming Faction
4. Arthur Wellesley, 1st Duke of Wellington
5. 1914-18 War Memorial to London Troops
6. The Earth is the Lord's and the Fullness Thereof
7. Ariel
8. Architectural Sculptures
9. Fulcrum
10. Broadgate Venus

The open-air sculpture scene in the City is complemented by the extensive array of funerary monuments in St Paul's Cathedral. One particularly poignant memorial here survived the Great Fire. This is Nicholas Stone's shrouded effigy of the poet John Donne. The equivalent treasure house in the West End is Westminster Abbey, whose monuments go back to the 13th century. The museums richest in sculpture are the British Museum, the Victoria and Albert Museum, and the Tate Galleries at Millbank and Bankside. The nation's open-air pantheons, where statues of monarchs, politicians and other eminent persons are assembled, are Parliament Square, Whitehall, the Victoria Embankment, Trafalgar Square, the Mall and Waterloo Place.

SCULPTURE IN THE REGION

The Albert Memorial in Kensington Gardens, recently restored by English Heritage, represents the high point of the Victorian Gothic revival. Not too far away, beside the Serpentine, is George Frampton's Peter Pan Memorial. On the way to these from central Westminster, passing the Victoria Memorial complex in front of Buckingham Palace, try to stop off at Hyde Park Corner where there are four fine monuments, including C.S. Jagger's powerful Artillery Memorial. Atop the adjacent Wellington Arch, now being restored by English Heritage, Adrian Jones's immense Quadriga group introduces drama to the skyline.

The great symbolist sculptor Alfred Gilbert can be best appreciated in his Earl of Shaftesbury Memorial Fountain, known as 'Eros' in Piccadilly Circus, and his Queen Alexandra Memorial Fountain at Marlborough Gate. Examples of direct carving from the 1920s and 30s are Eric Gill's Ariel and Prospero on the BBC Headquarters in Portland Place (1932), and Day and Night by Jacob Epstein on the London Transport Headquarters, 55 Broadway, where Gill's work can also be seen. Henry Moore and other, less eminent sculptors of the day are also represented here. One has to go further afield to find Henry Moore at his best. His Three Standing Figures in Battersea Park are decidedly worth the detour.

Other memorable sculptures are also found further from the centre; Paddington Green has Mrs Siddons in marble by Chavalliaud, and Oscar Nemon's seated bronze of Sigmund Freud has been resited outside the Tavistock Centre at Belsize Park. London's developing Docklands in the 1980s and 90s built a varied collection of work, showing sculptures like Allen Jones's Dancers in painted steel at London Bridge, or the series of three pieces at the Limehouse Link Tunnel, two in Cor-Ten steel (Zadok Ben-David and Nigel Hall), and one by

Michael Kenny, entitled On Strange and Distant
Islands, in Kilkenny limestone. Antony Gormley
contributed Millennium Man to the Dome
sculpture commissions at Greenwich. The borough
of Merton has a continuing policy of new
commissions, particularly set in Cannizaro Park:
David Mach's tilting telephone boxes and other
late 20th-century work can be seen in Kingston-
on-Thames.

Date / / Location > Subject >

Date / / Location > Subject >

All cities publish local interest guides including sculpture trails, maps and information leaflets. Information is available from local authority information sections or Tourist Information Centres, the City Art Gallery and Museum and, for more serious enthusiasts, the local history section of the public library. Local libraries give information on books or booklets on public sculpture, or lives of people or events portrayed in public sculptures. Some publications are out of print but can be consulted at the reference library.

GENERAL INFORMATION & BOOKLIST

Groups like the Fountain Society, Twentieth Century Society (or locally, the Hampshire Sculpture Trust), the public Monuments and Sculpture Association and others, mostly London based, give information on written request. Some universities publish local information. There follows an alphabetical selection of general publications: those with an asterisk are retailing now.

*The Buildings of England** associated with name of original sole author Sir Nikolaus Pevsner, published county by county by Penguin Books; mainly architecture but some counties focus well on public sculpture; in process of updating. *Dictionary of Sculptors in Bronze* by James Mackay (Antique Collectors Club 1977). *Garden Sculpture** by Michael Symes (Shire Publications, 1996). *The Monument Guide to England and Wales* by Jo Darke (Macdonalds Illustrated, 1991). *Open Air Sculpture in Britain* by W.G. Strachan (Zwemmer, 1984). *Public:Art:Space** by Mel Gooding (Merrell Holberton, 1998). *Victorian Sculpture** by Benedict Read (Yale, 1982). Regional publication: *leaving tracks: artranspennine98 - a record of the exhibition*, ed. Nick Barley (August Media/Art Transpennine Ltd, 1999). PMSA publications under way *Public Art of Britain* series (Liverpool University Press); *Public Art of Birmingham* by George Noszlopy (1998); *Public Art of Liverpool* by Terry Cavanagh (1999); *Public Sculpture of North-East England* by Paul Usherwood, Jeremy Beach and Catherine Morris (May 2000). SusTrans, based in Bristol, have material about sculptures on their Cycle Network. *At the Going Down of the Sun, British First World War Memorials** by Derek Boorman (Ebor Press, York 1988). *For Your Tomorrow, British Second World War Memorials** by Derek Boorman (Ebor Press, York 1995). *War Memorials from Antiquity to Present** by Alan Borg (1991).

Introduction by Richard Cork.

Regional sections by Richard Barnes, Jeremy Beach
and Stuart Burch, Sian Everitt, Douglas Merritt,
Jane Mitchell, Paul Usherwood, Ann Wadman,
Philip Ward-Jackson and Terry Wyke - members
and friends of the National Recording Project of
the Public Monuments and Sculpture Association.

Text devised and edited by Johanna Darke (PMSA).

Gallery photographs by Al Deane and
Barry Cawston, Boris Baggs Studio

Sincere thanks are due to Ian Leith (English
Heritage and PMSA) for his untiring assistance,
and to many other advisers whose knowledge has
been invaluable.

Despite the care that has been taken, errors will
occur. The PMSA is always grateful to receive
information and updates on public sculptures.

ACKNOWLEDGEMENTS

Sculpture is the language of architecture
Charles Robert Cockerell

The Public Monuments and Sculpture Association was formed in 1991 to enhance public appreciation of public sculpture and to spread information about this fascinating subject - a combination of visual art and social history. A charity funded by its subscribing members, the PMSA sets up events, organises lectures and conferences, publishes a newsletter and works for better understanding in the care of public sculptures. Among other concerns it encourages public dialogue on outdoor art, and campaigns for improved working practice in conservation.

The PMSA issues an annual journal devoted to sculpture; it is associated with the Royal Society of Arts' Trafalgar Square Plinth campaign, and other key public art issues such as the listing and care of architectural sculpture. Its principle concern, supported by lottery and other funding, is the National Recording Project which, in 14 regional archive centres, is building a computerised archive of public sculpture and monuments nationwide.

PUBLIC MONUMENTS AND SCULPTURE ASSOCIATION

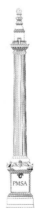

English Heritage

Customer Services

PO Box 569

Swindon SN2 2YR

Telephone 01793 414 910

Email: members@english-heritage.org.uk

information is also constantly updated on our internet

website. Find us at: http://www.english-heritage.org.uk

ENGLISH HERITAGE